Adorable Animals

GRAYSCALE
COLORING BOOK

Jane Maday

NORTH LIGHT BOOKS

Contents

Learn to Color Grayscale 8

Before you get started, learn the basics of grayscale coloring, from the best tools to choose to simple techniques you can use to achieve gorgeous results.

Grayscale Coloring Pages 17

Relax and unwind with 48 adorable, fully-rendered animal coloring pages.

Inspiration Gallery . 112

Not sure where to begin? Refer to the inspiration gallery for coloring ideas and to enjoy the fully colored artwork.

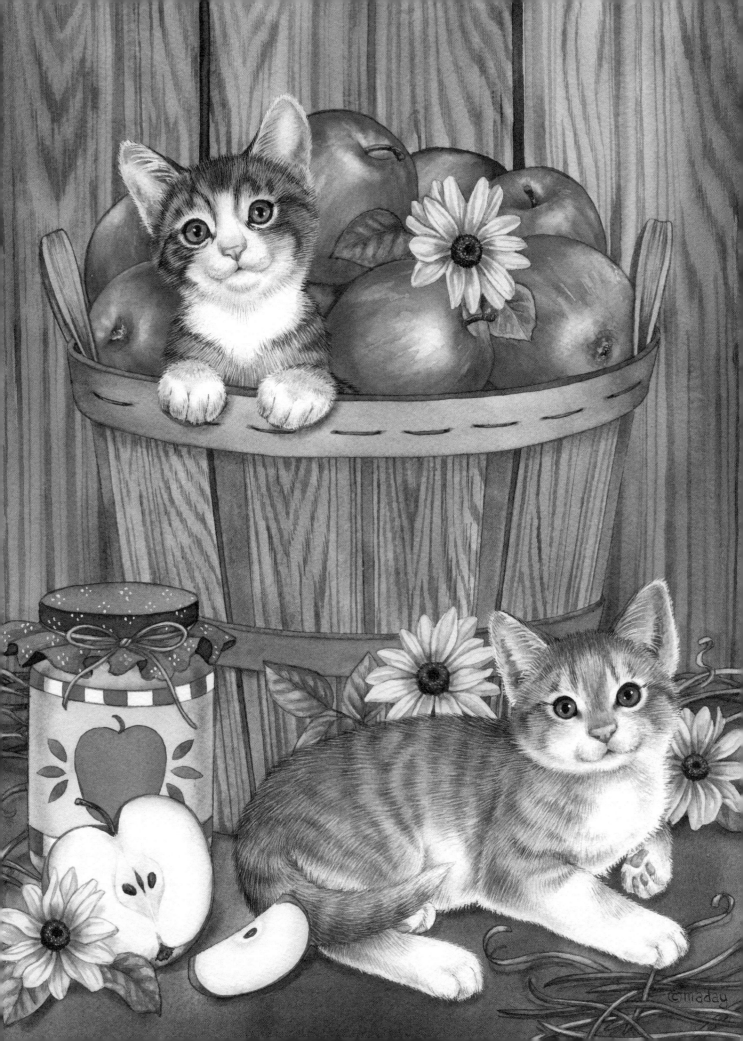

This book
colored by

An Introduction to Grayscale Coloring

Grayscale coloring is a fun new trend where you color on top of an already shaded image rather than inside linework. This helps you achieve a beautiful "painted" effect because all the lights and darks are already figured out for you! In grayscale coloring, the main thing you need to remember is to color the light areas with light colors and the dark areas with dark colors. I like to work from light to dark, gradually building up layers of color.

When selecting your coloring medium, keep in mind that you want to use products that are fairly transparent so the shading shows through. My favorite medium for grayscale coloring is colored pencils, but you can also use markers, soft chalk pastels or watercolor pencils. Steer clear of regular crayons or oil pastels because they are generally too opaque.

To get started, check out the first few pages of tips, techniques and practice pages. For color inspiration and ideas, refer to the fully colored versions of each grayscale image in the back of the book.

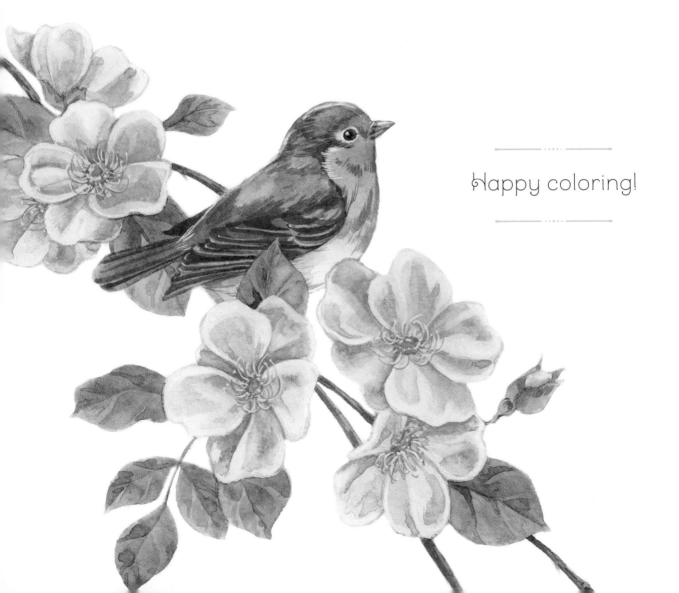

Happy coloring!

7

Coloring Tools

SOFT CHALK PASTELS

Chalk pastels, whether in stick or pencil form, work well for a nice, soft effect. I like to blend them with a cotton swab.

MARKERS

Markers can be alcohol-based like Copics, water-based like brush pens from Tombow, or ink-based like Faber Castell Artist Pens. Some markers, especially alcohol-based, will bleed through the paper.

WATERCOLOR PENCILS

Watercolor pencils create gorgeous effects. I like to color with them like a regular pencil, then go over the marks with a damp brush to activate the watercolor.

COLORED PENCILS

Colored pencils are usually either wax- or oil-based. They vary in hardness so experiment until you find the ones that are right for you.

Comparison of Coloring Mediums

This bunny has been colored with a few different mediums. Whatever you choose, it is best to pick a medium that is fairly transparent so your shading shows through.

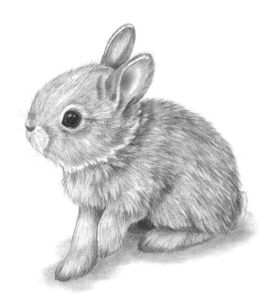

Grayscale

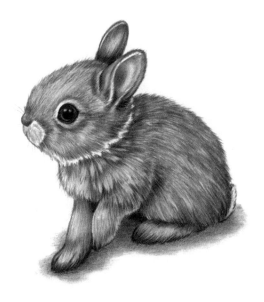

Colored Pencils

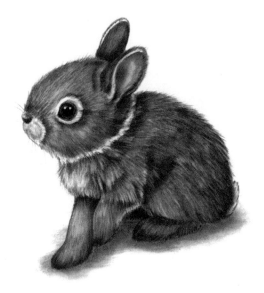

Brush Markers

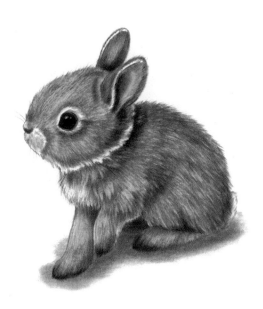

Pastel Pencils

Combining Mediums

You don't have to limit yourself to one medium when completing a grayscale coloring page. Combining different mediums is fun because you get to play with all of your coloring toys!

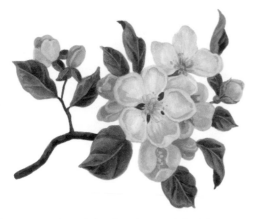

1 To begin, I colored the first layer of the blossoms with Copic markers.

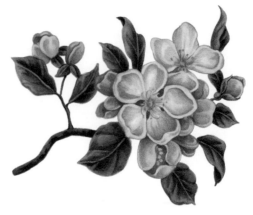

2 I followed the marker with a layer of colored pencils.

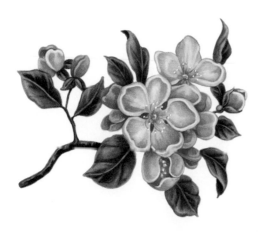

3 I added highlights with a white gel pen and some lighter colored pencils.

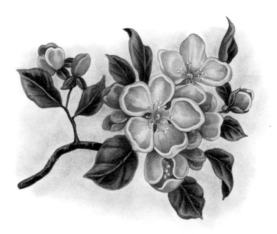

4 To finish the drawing, I added the sky behind the blossoms with soft chalk pastels and a cotton swab.

Transparent vs. Opaque

It is important to use your pencils in transparent layers. Practice applying color with heavy and light strokes so you can learn the different effects that each creates.

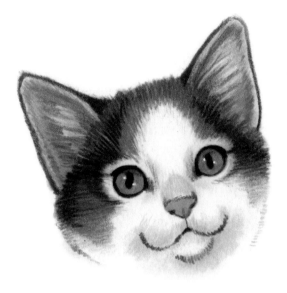

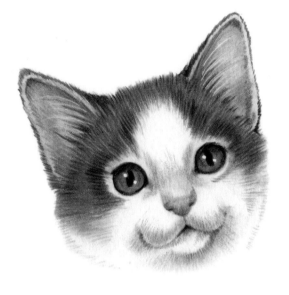

Opaque Example
This kitty was colored using soft pencils by Prismacolor with a heavy application for opaque layers.

Transparent Example
This kitty was colored using slightly harder pencils by Faber Castell with a lighter application for transparent layers.

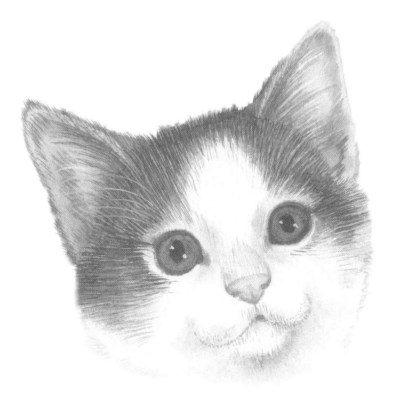

Use this grayscale image for practice! Color right on this page or feel free to make a copy.

Layering to Create Depth

Create a richness in your work by adding layers of color. In this exercise, practice adding a glow to the red apple by starting with a light yellow layer.

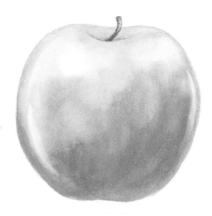

1 Use this grayscale image for practice. Color right on the page or feel free to make a copy.

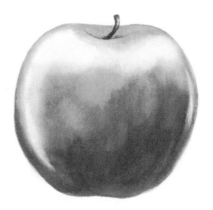

2 Using watercolor pencils, color the apple yellow leaving some white areas for highlights.

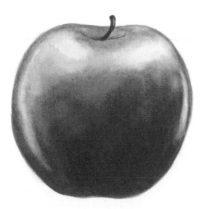

3 Add a layer of red. Leave some yellow showing so the new red layer doesn't look too flat.

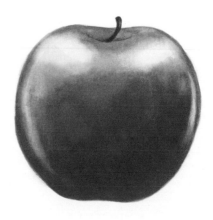

4 Finally, add another layer of darker red to deepen the shading of the entire image. Touch up the final piece with some highlights.

Coloring Light to Dark

When coloring grayscale, I like to work light to dark. Try to use only light colors for the light areas and dark colors for the dark areas.

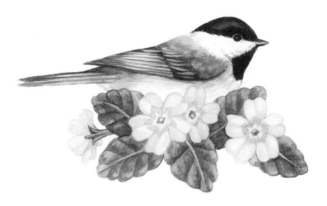

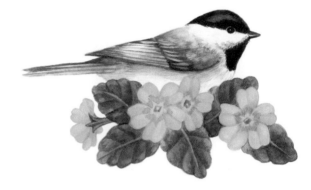

1 Use this grayscale image for practice. Color right on the page or feel free to make a copy.

2 Using the grayscale drawing as a guide, color the lightest areas with watercolor pencil.

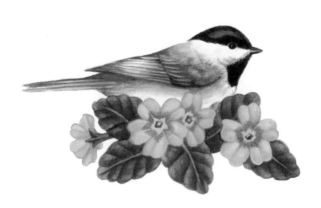

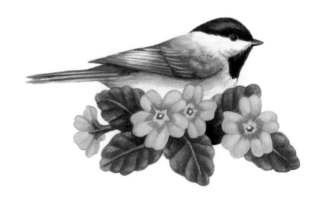

3 Add the medium tones using watercolor pencils.

4 Add the darkest tones last. I used a little bit of white paint for the highlights on the flower centers and the bird's eye.

Coloring Fur

The secret to coloring fur is to use soft transparent layers. You may want to spray workable fixative between each layer to prevent smudging.

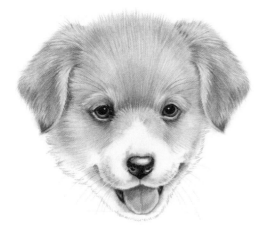

1 Use this grayscale image for practice. Color right on the page or feel free to make a copy.

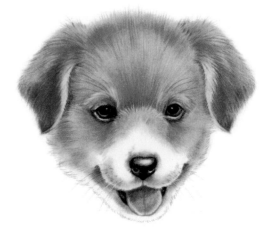

2 For extra softness, start with a layer of soft chalk pastels. Here I used PanPastels.

3 Switch to colored pencil and make sure your strokes follow the direction of the fur's growth. That way your strokes will taper nicely at the ends.

4 To finish, go over the lightest colored fur with a cream colored pencil to help burnish it smooth. Add a few highlights using a white gel pen on the eye, nose and tongue.

Practice Makes Perfect!

Before you begin a full coloring page, practice on
these individual images to get the hang of it.

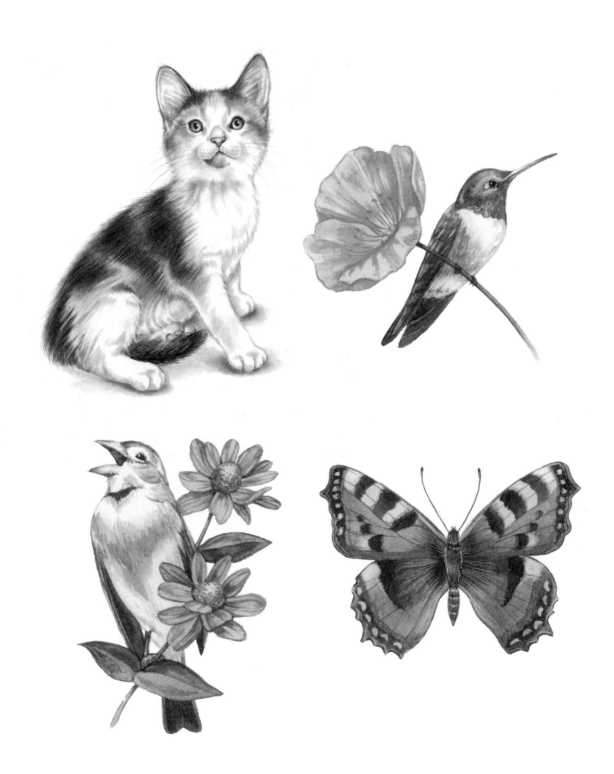

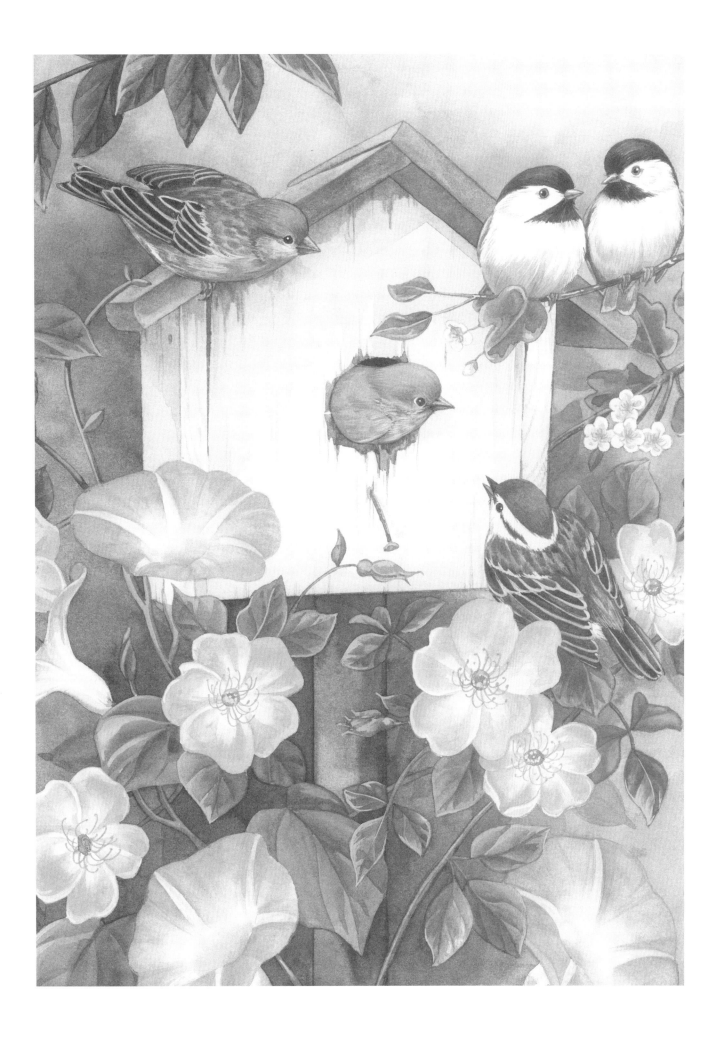

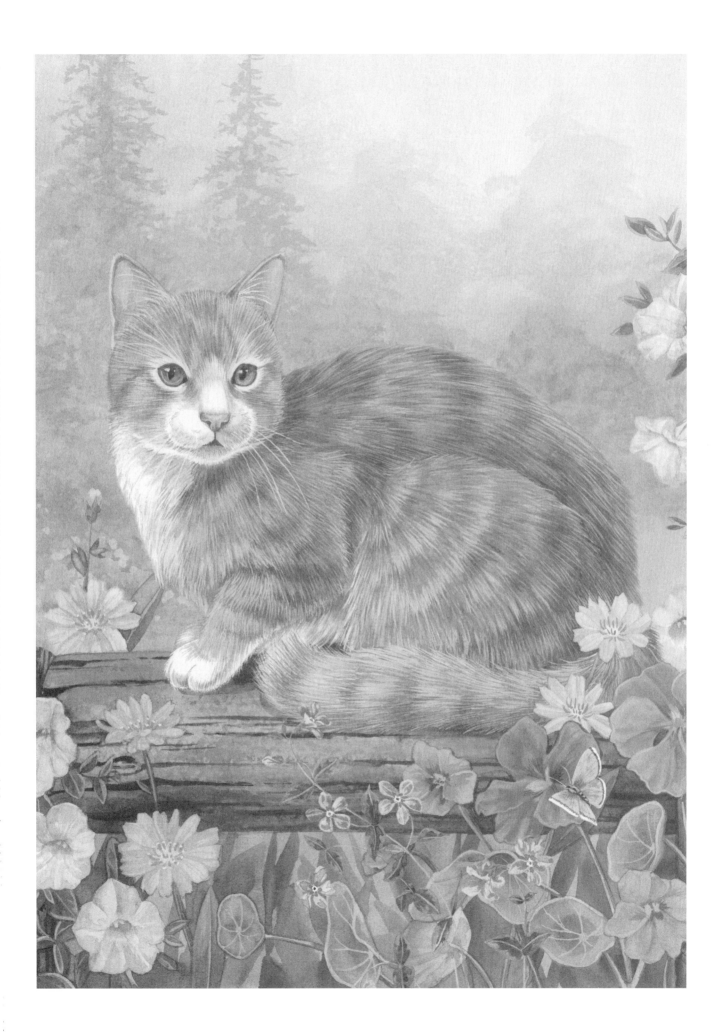

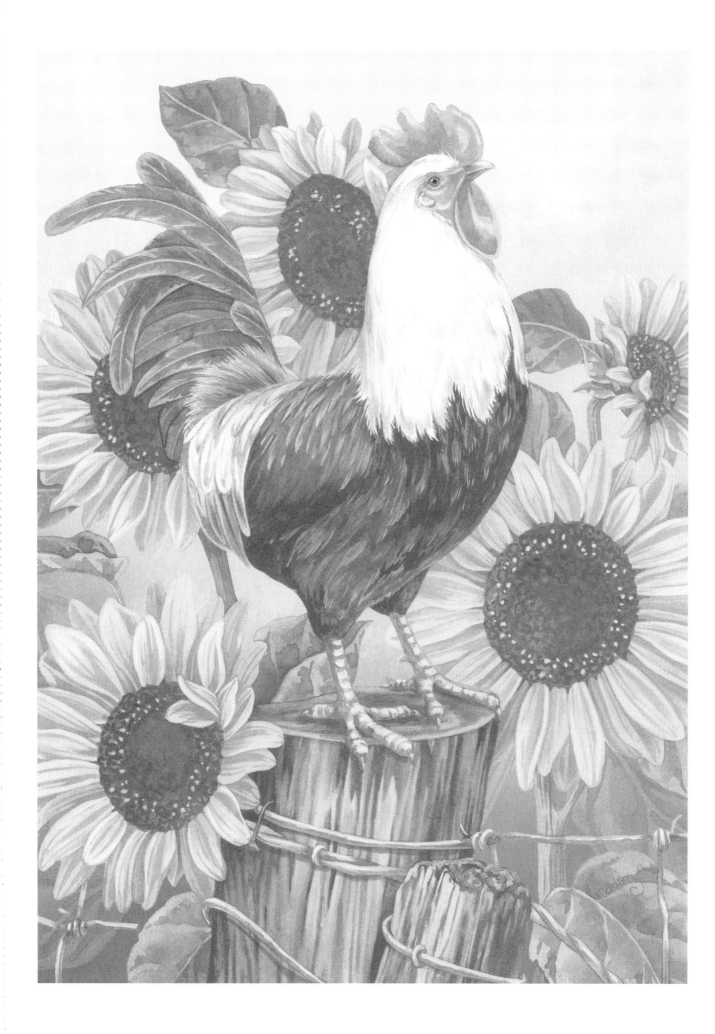

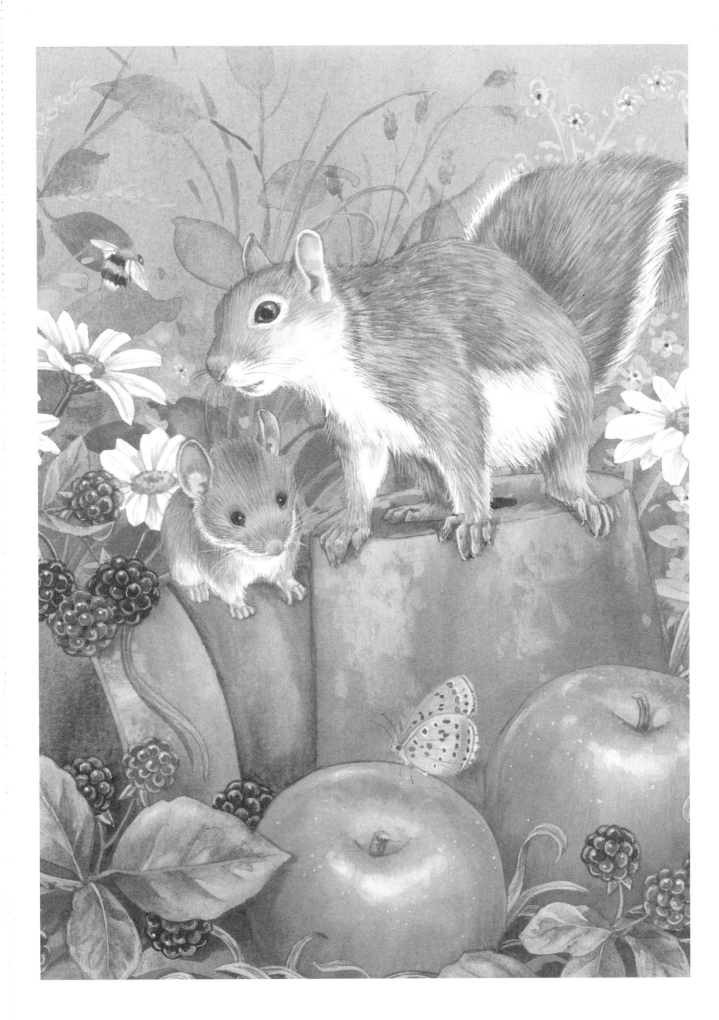

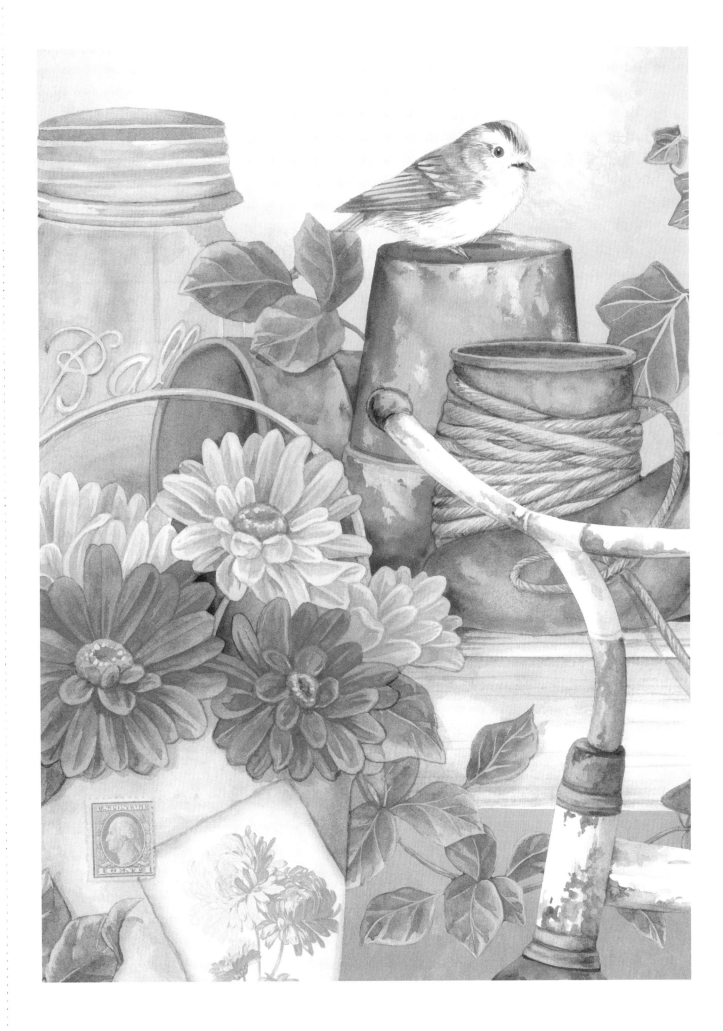

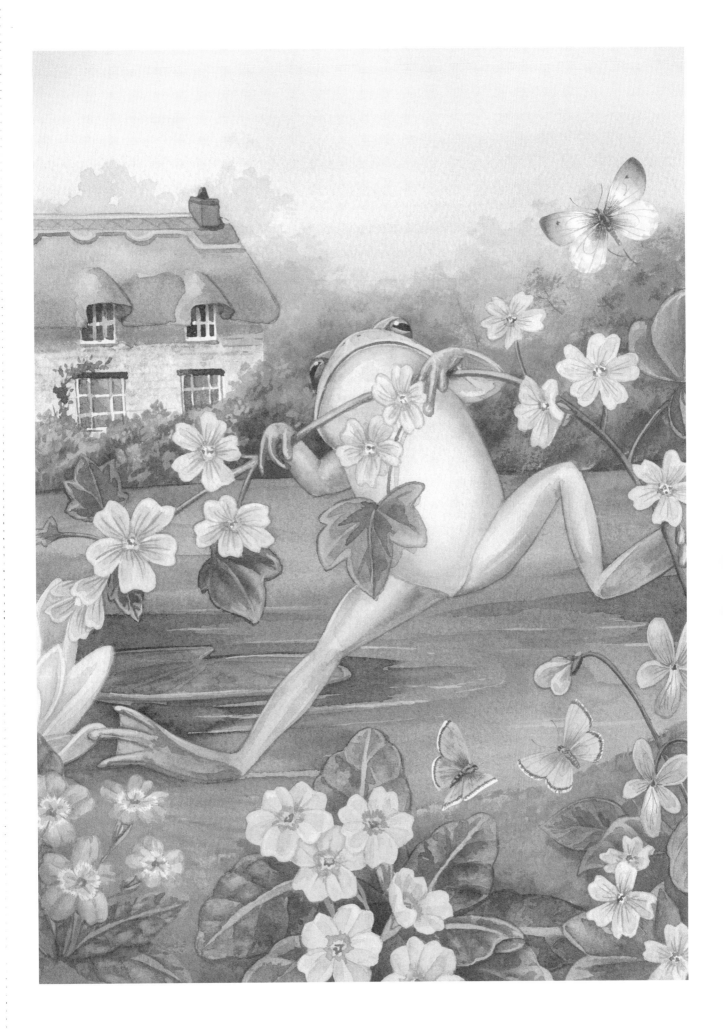

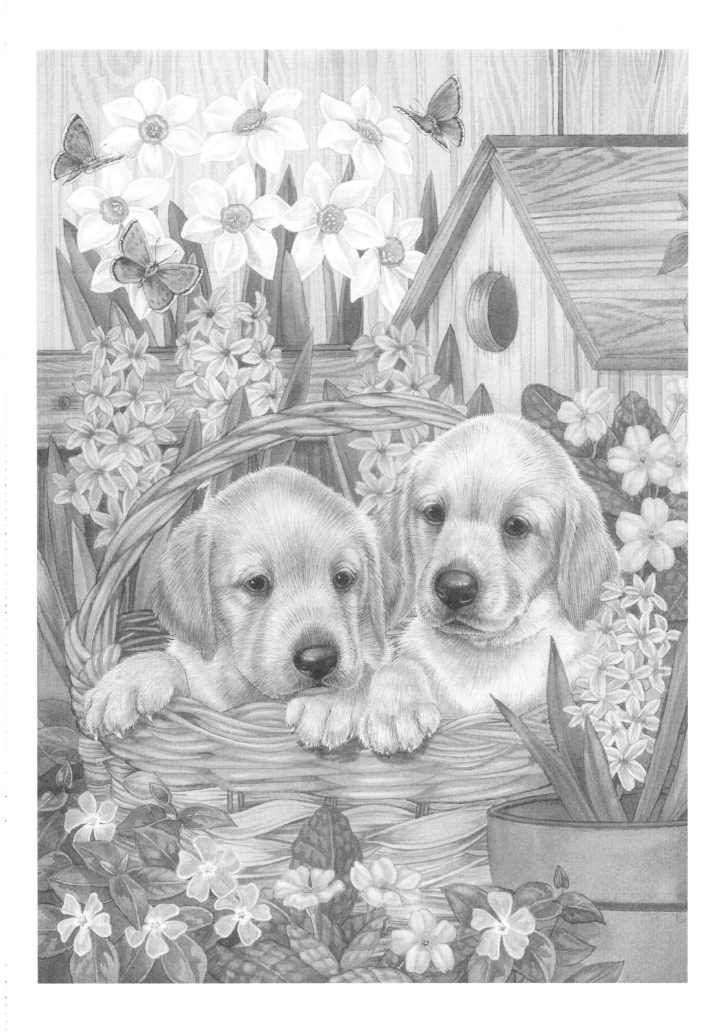

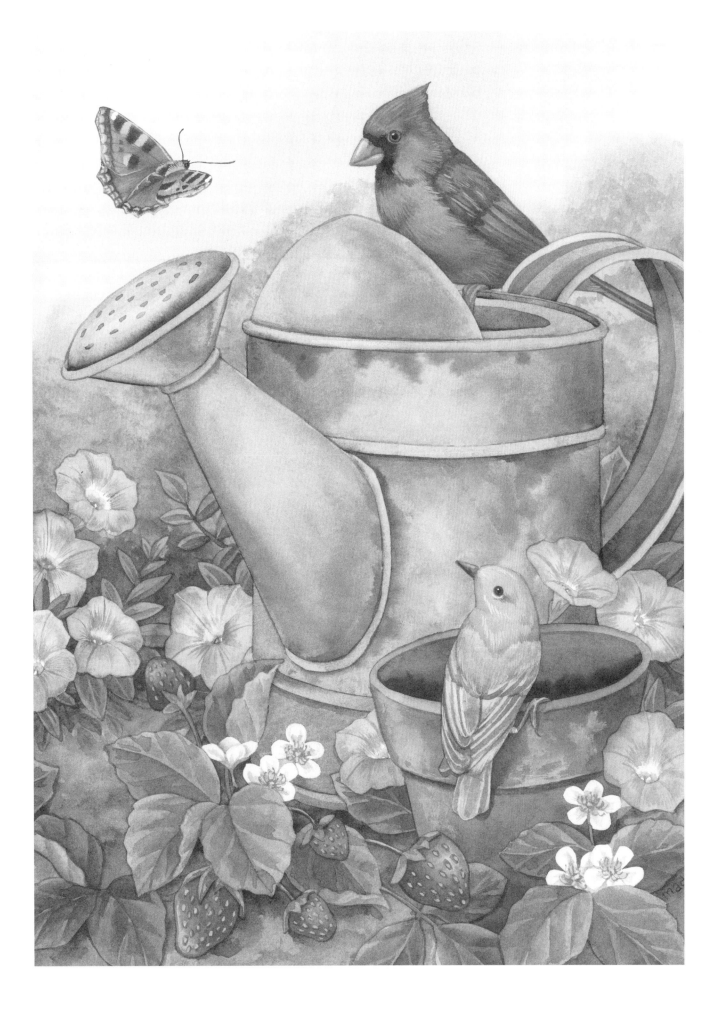

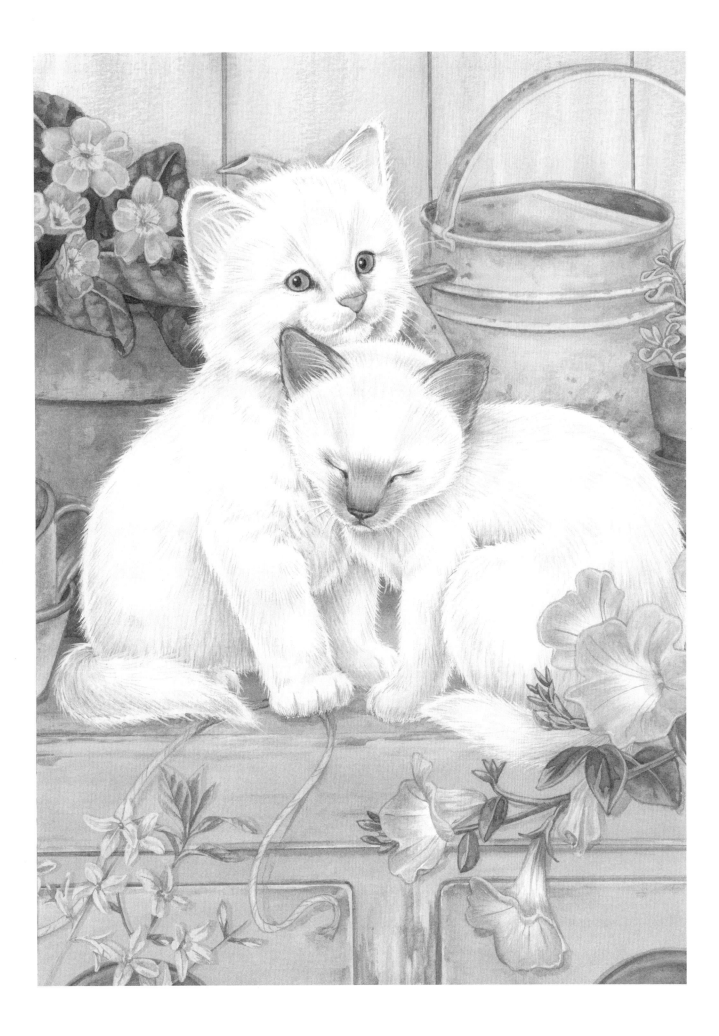

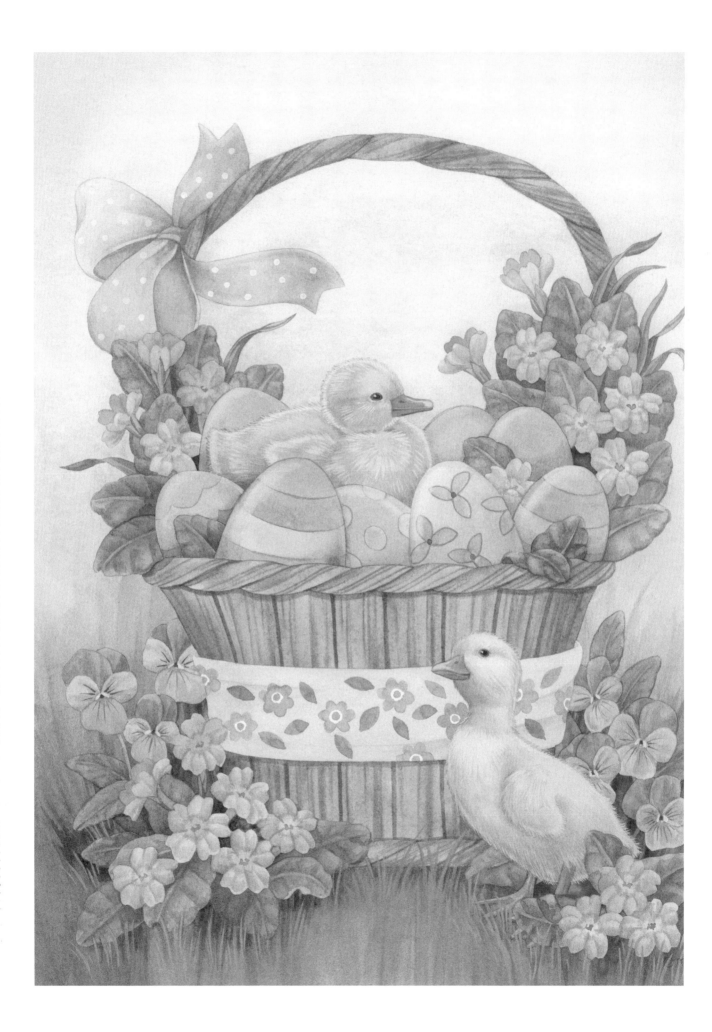

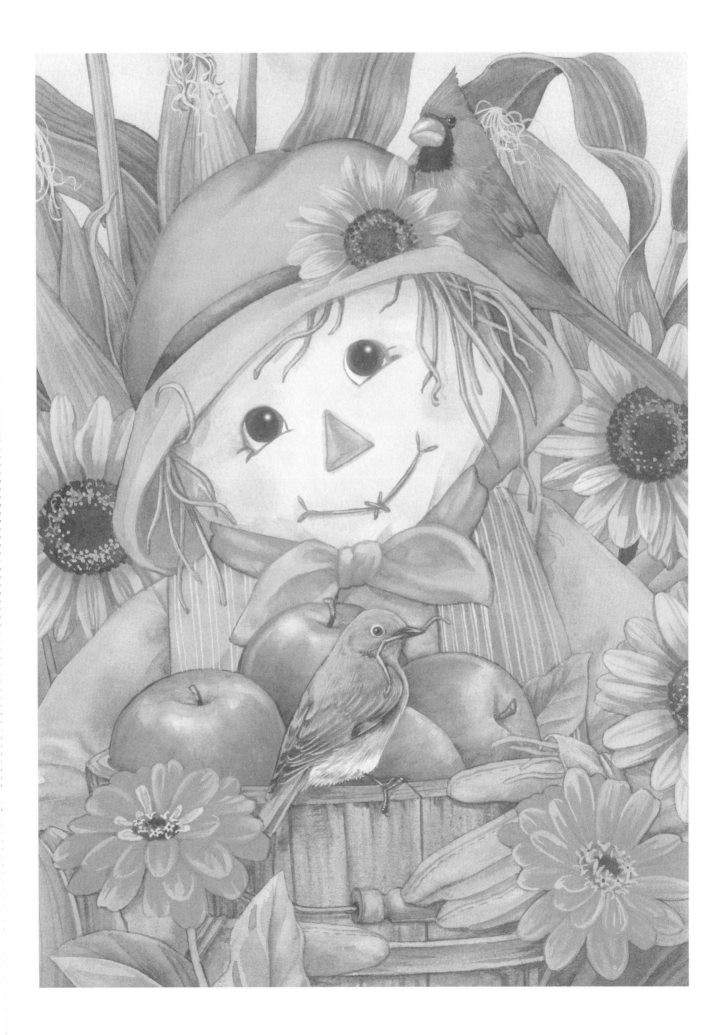

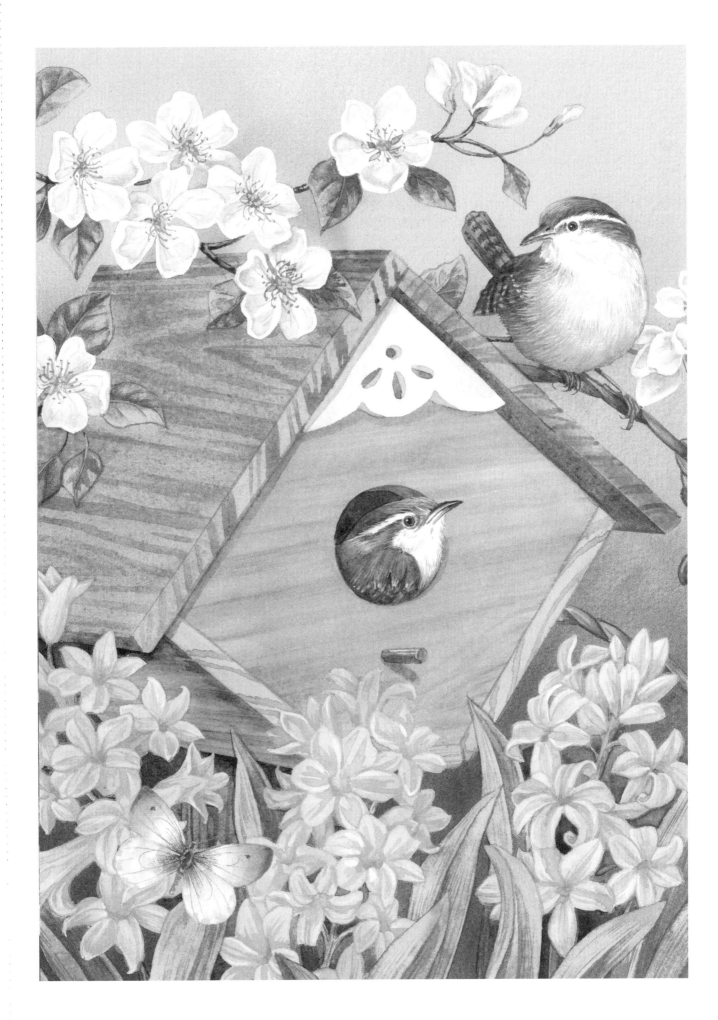

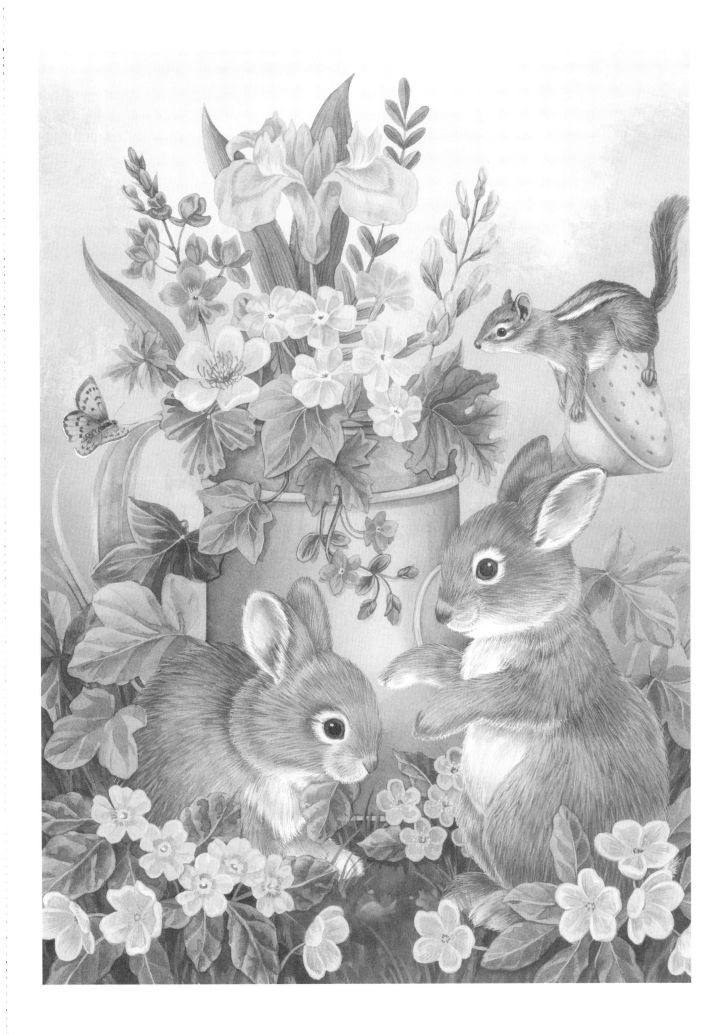

42

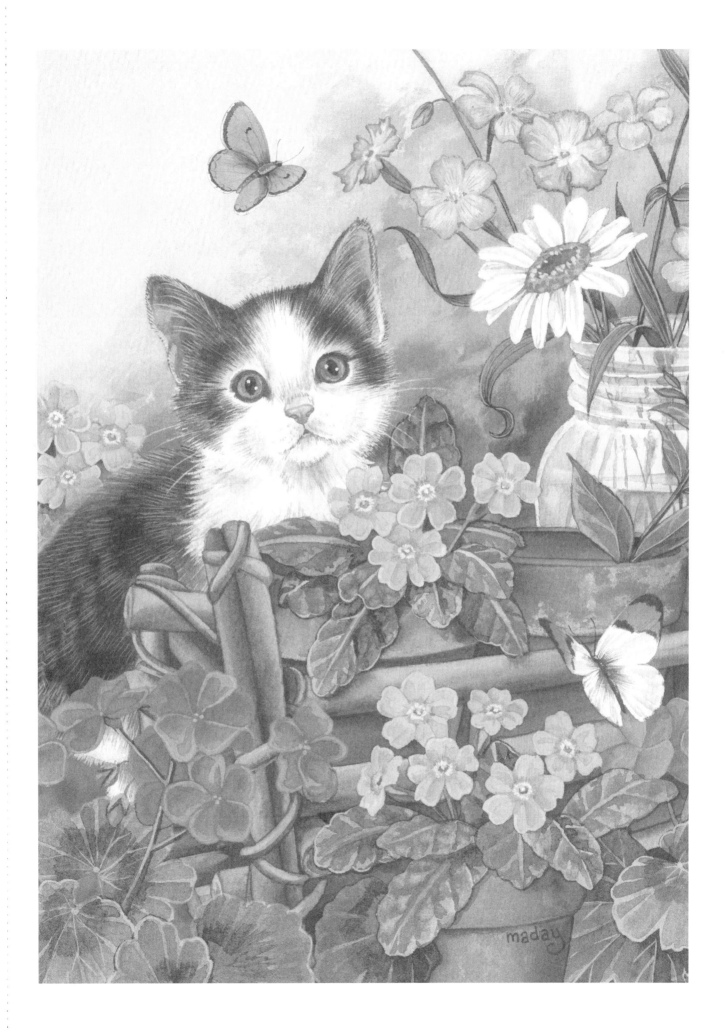

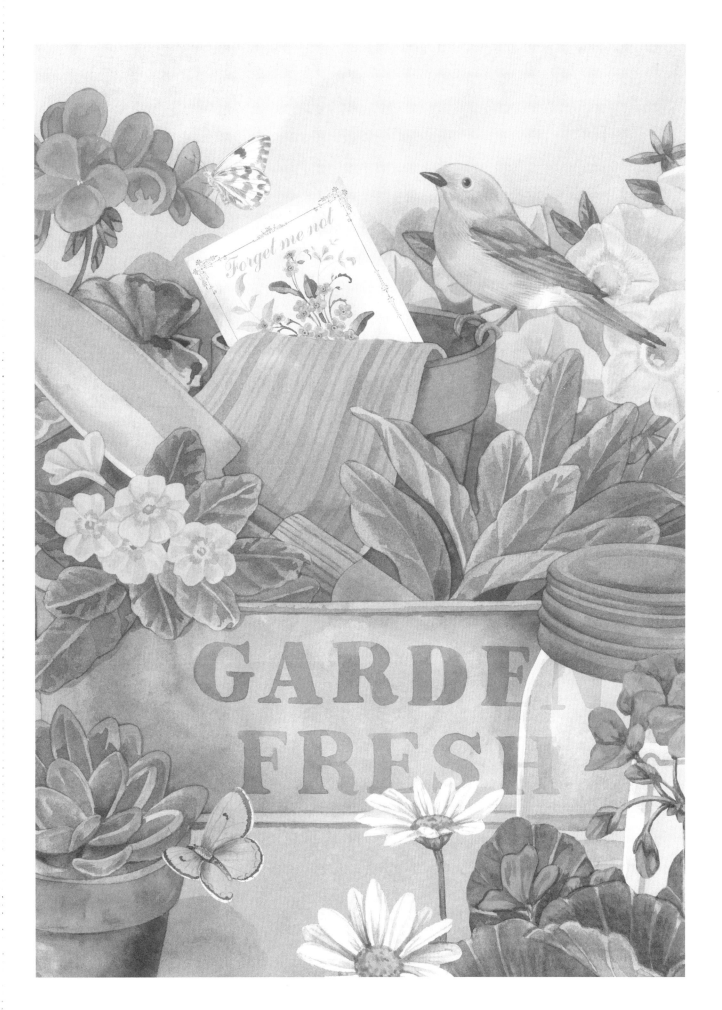

Forget me not

GARDEN
FRESH

46

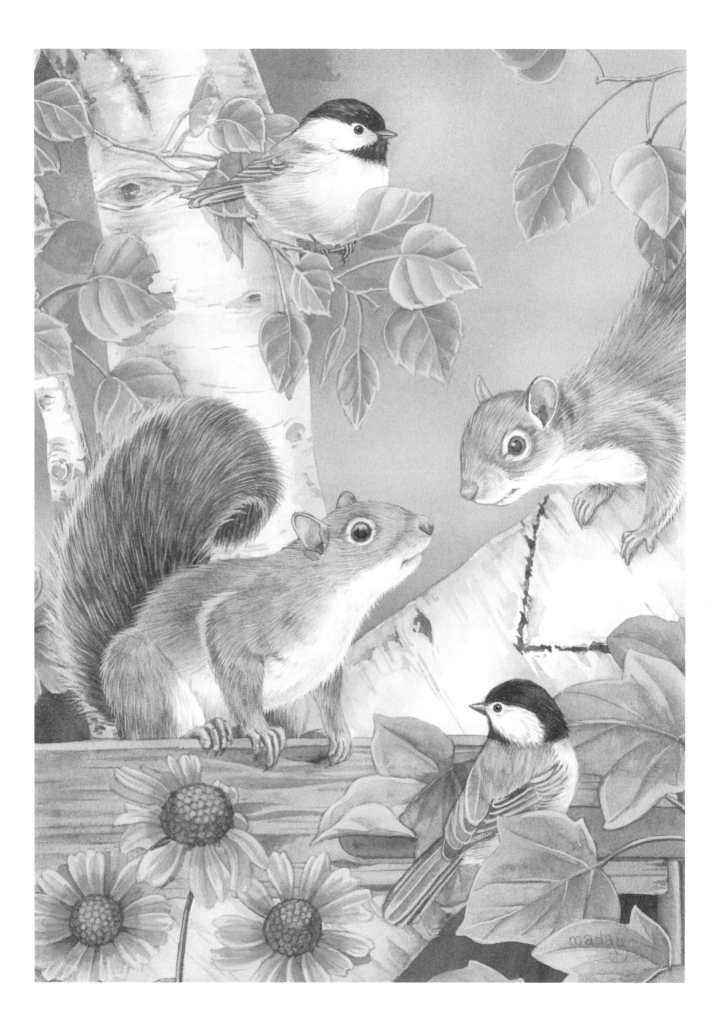

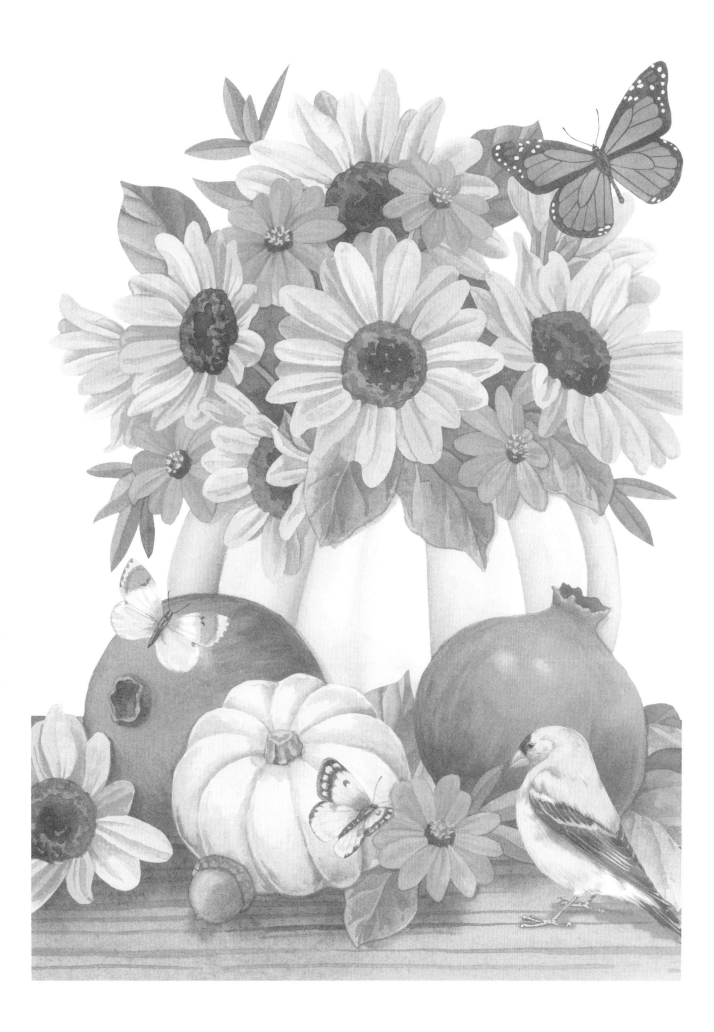

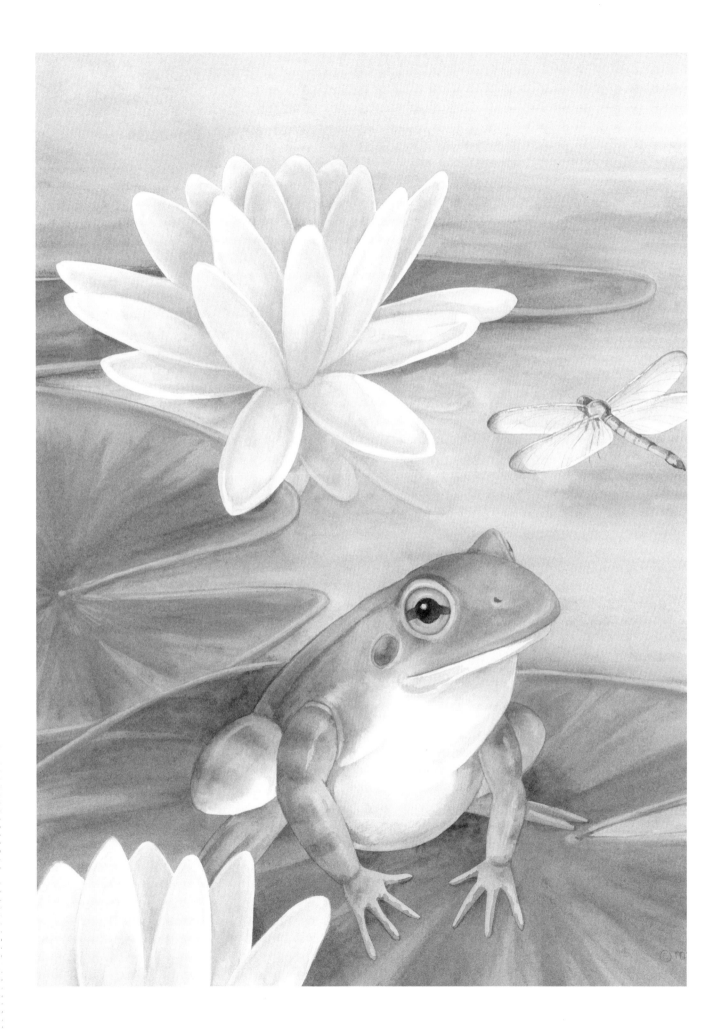

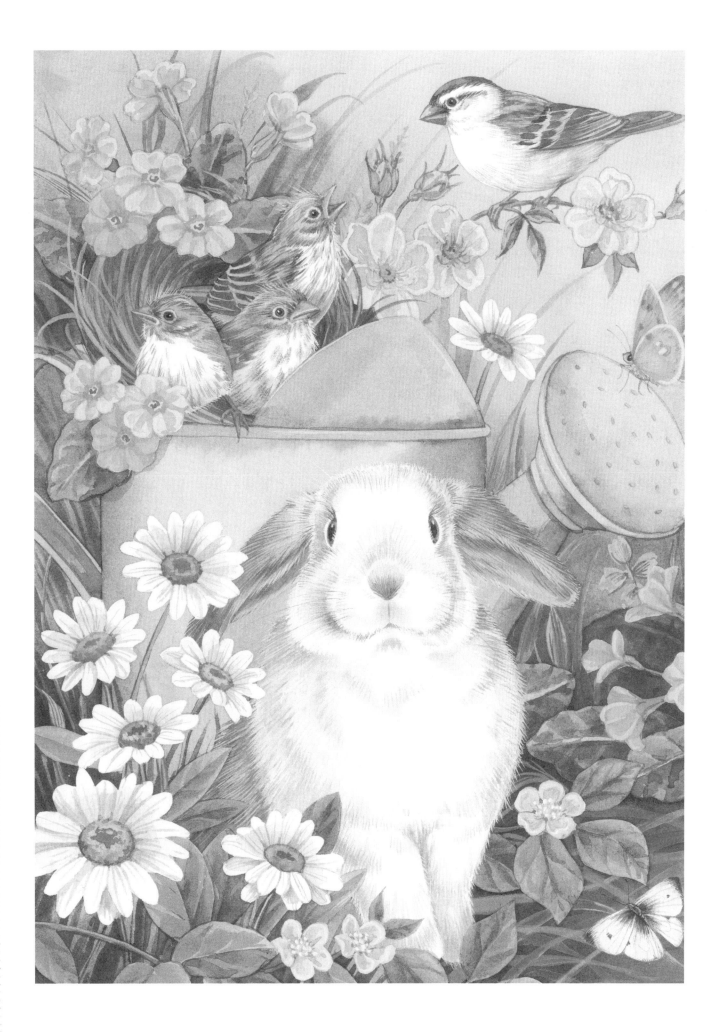

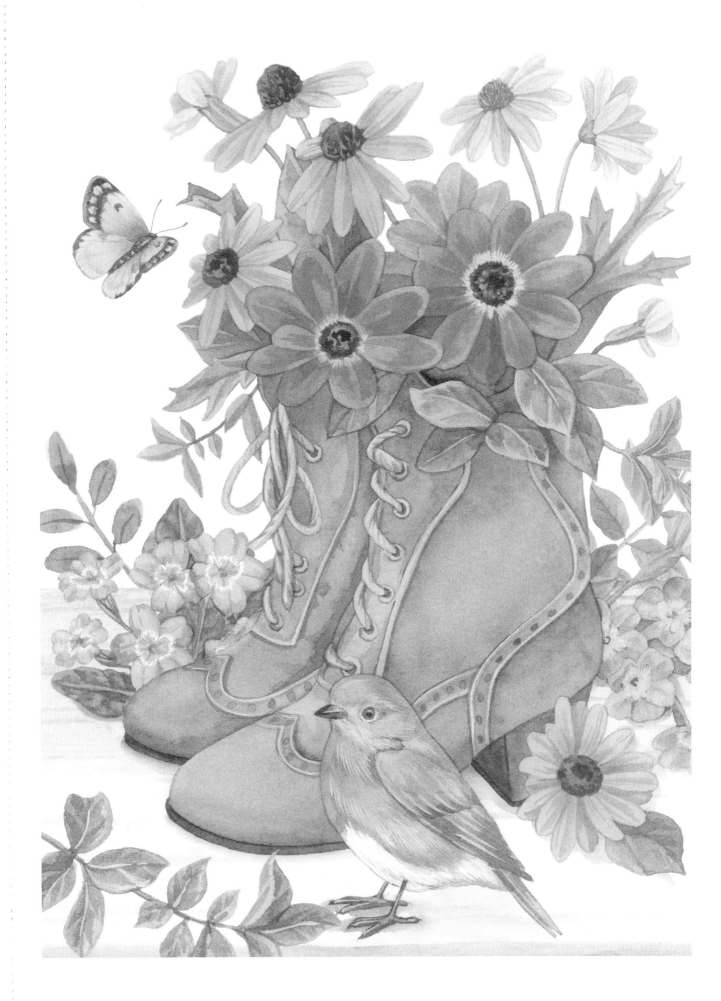

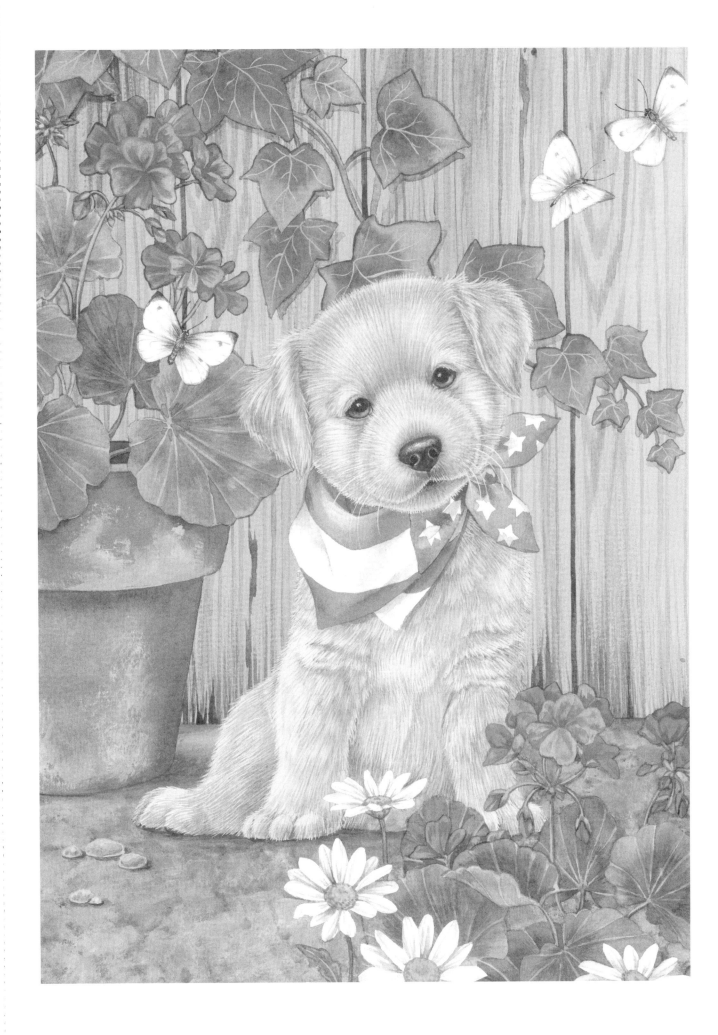

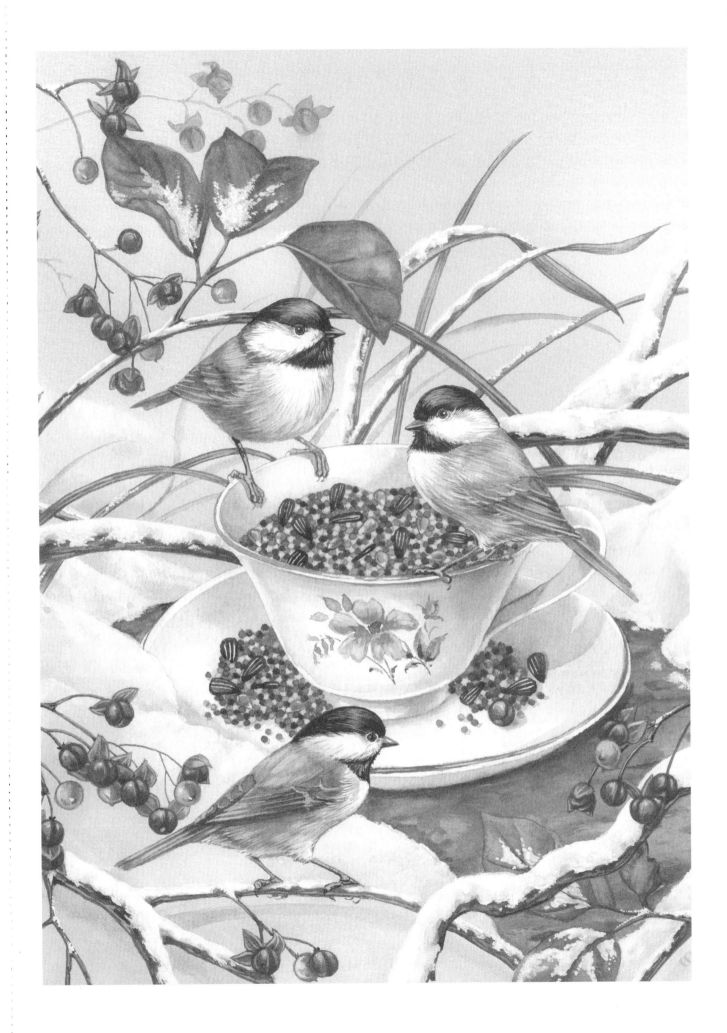

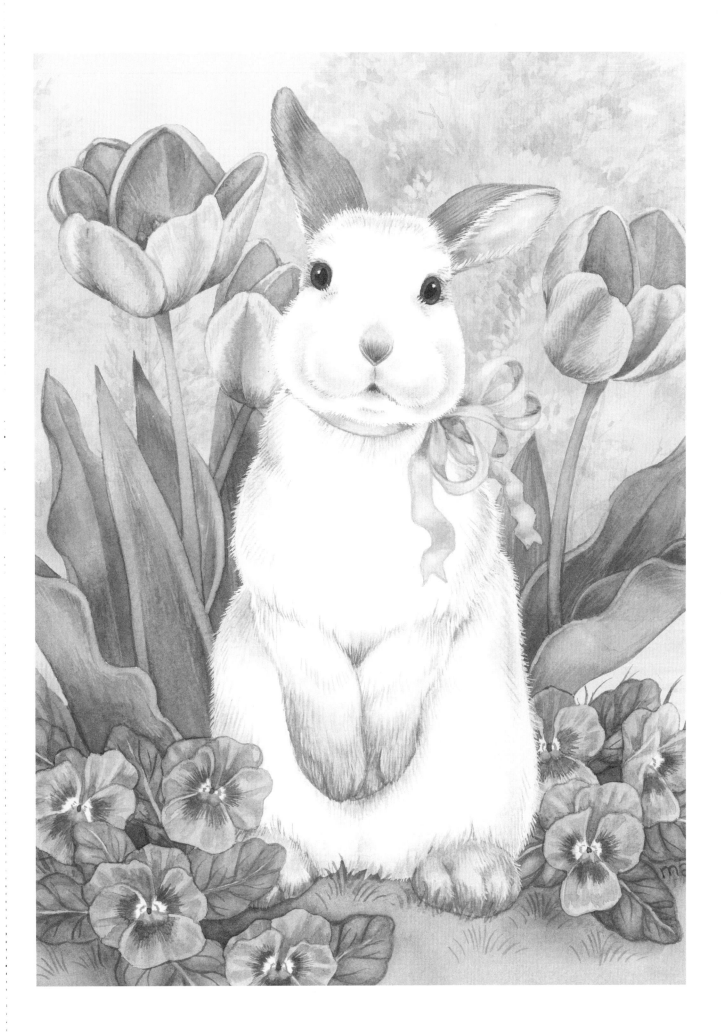

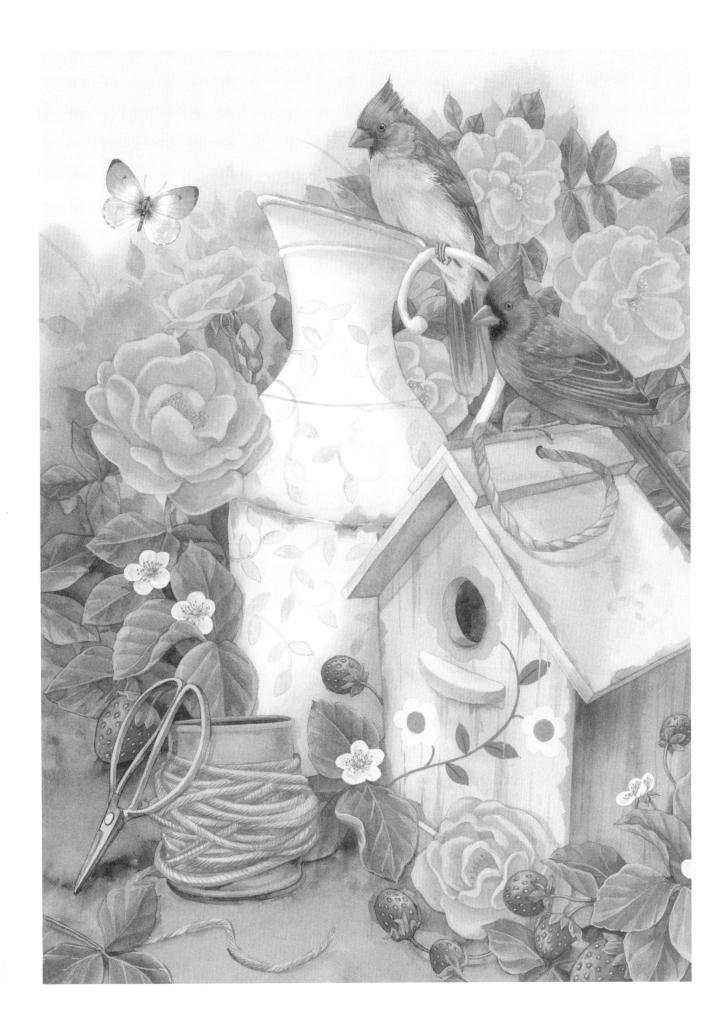

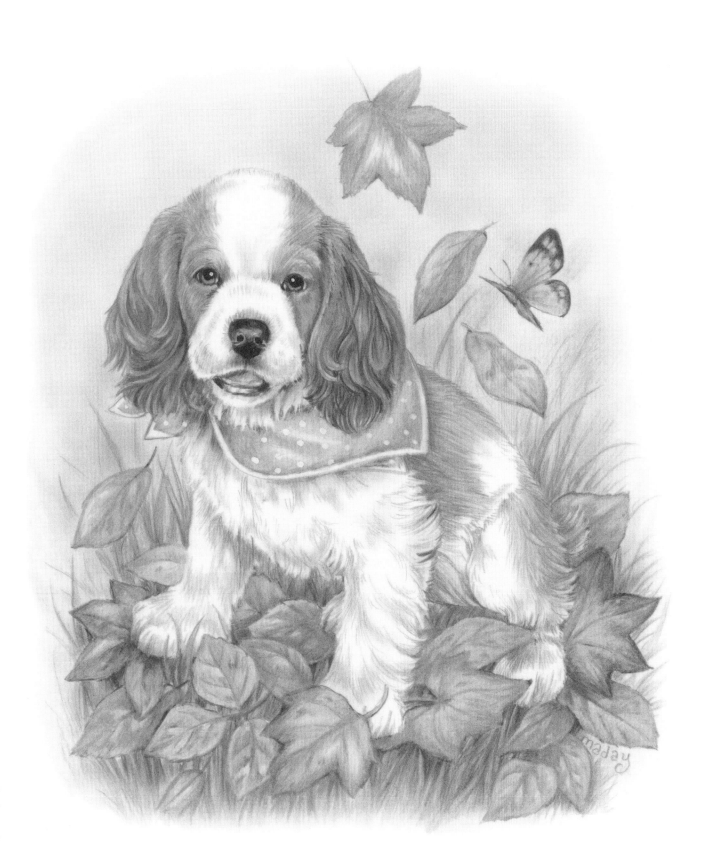

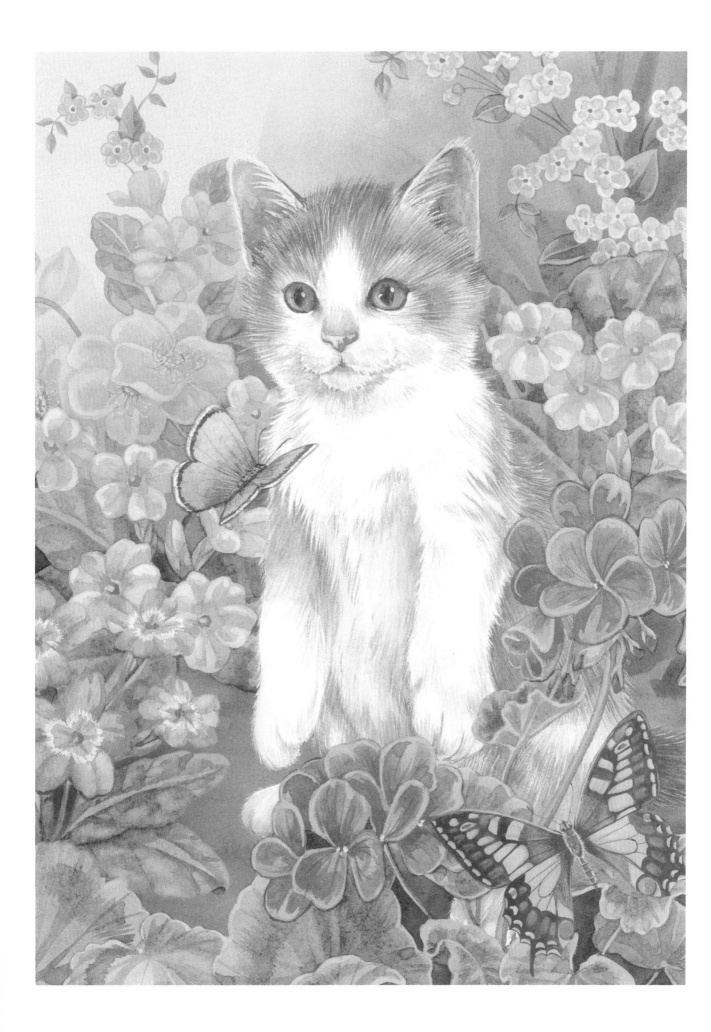

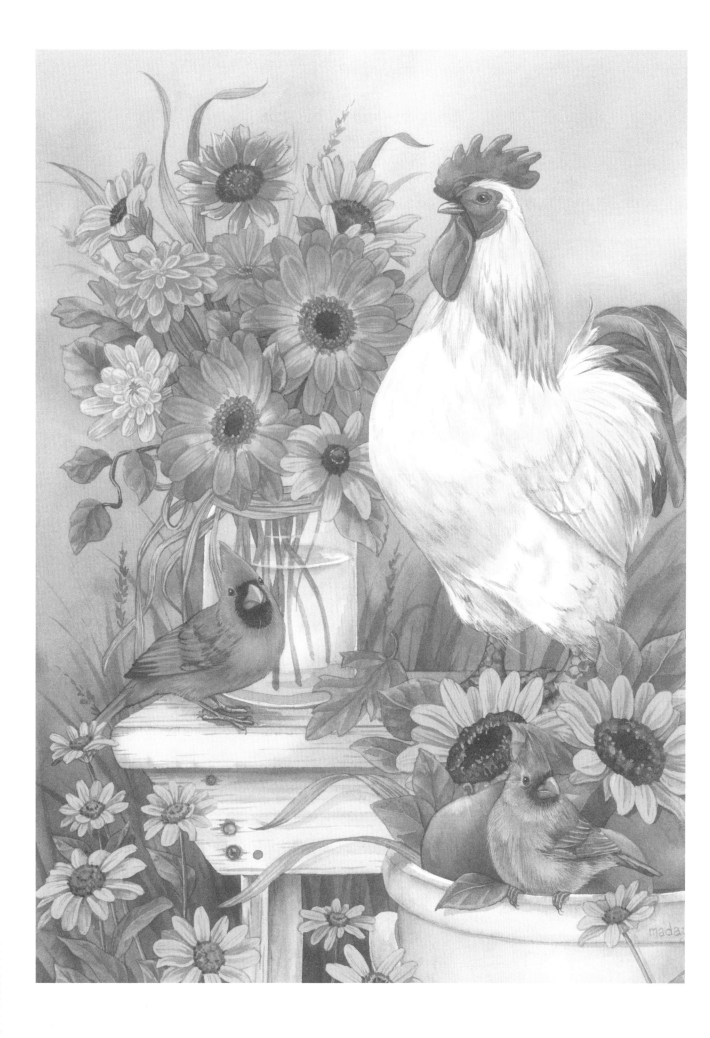

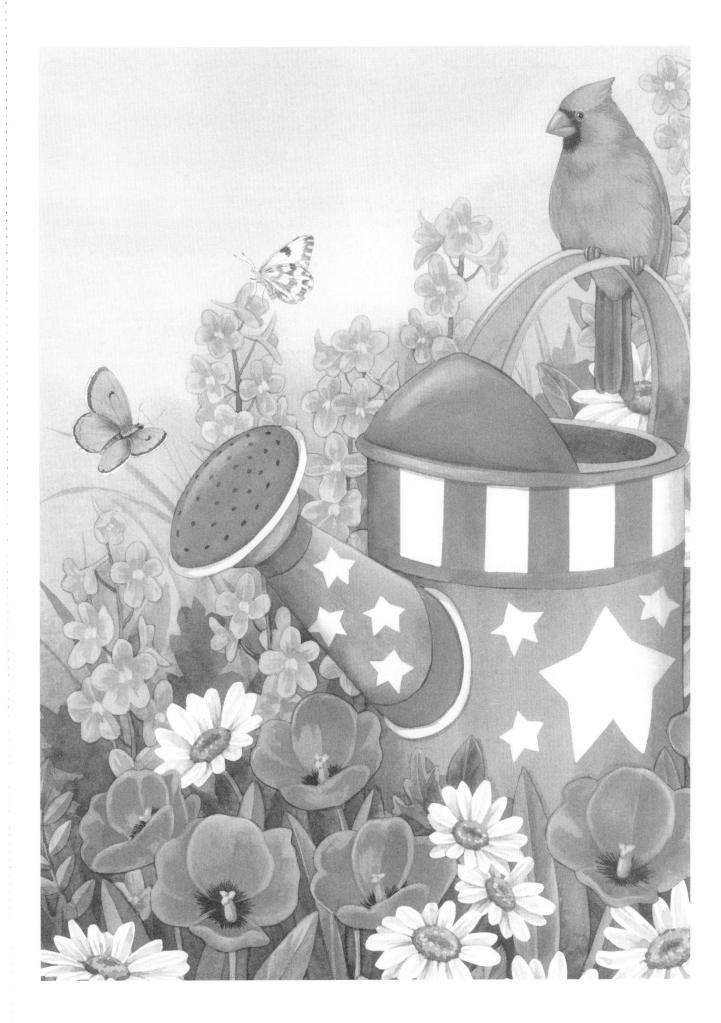

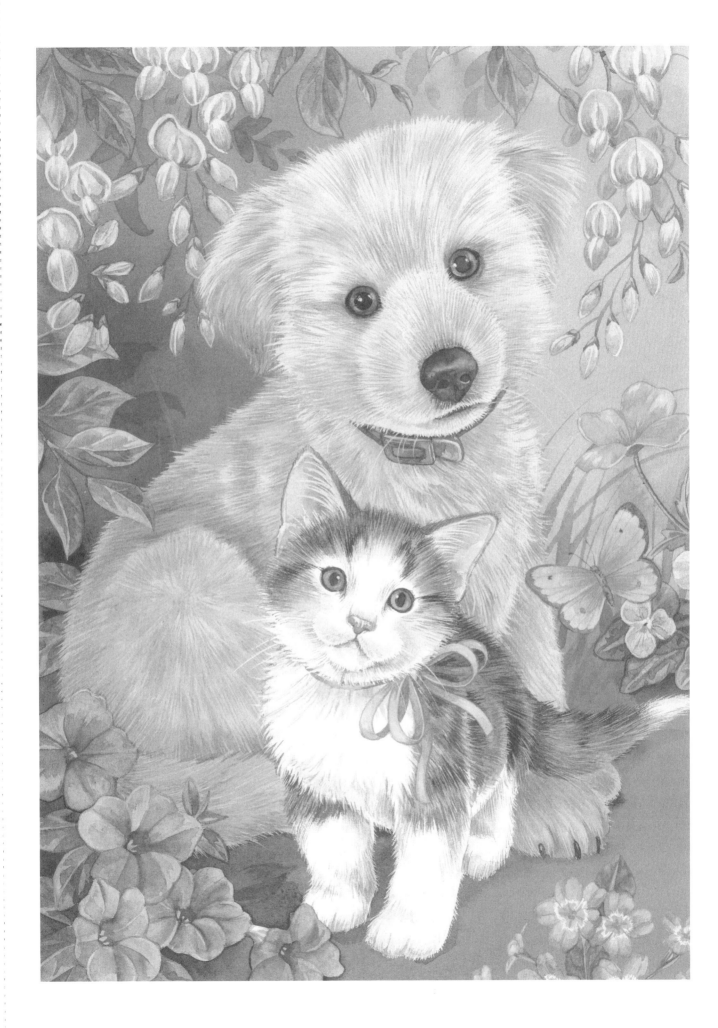

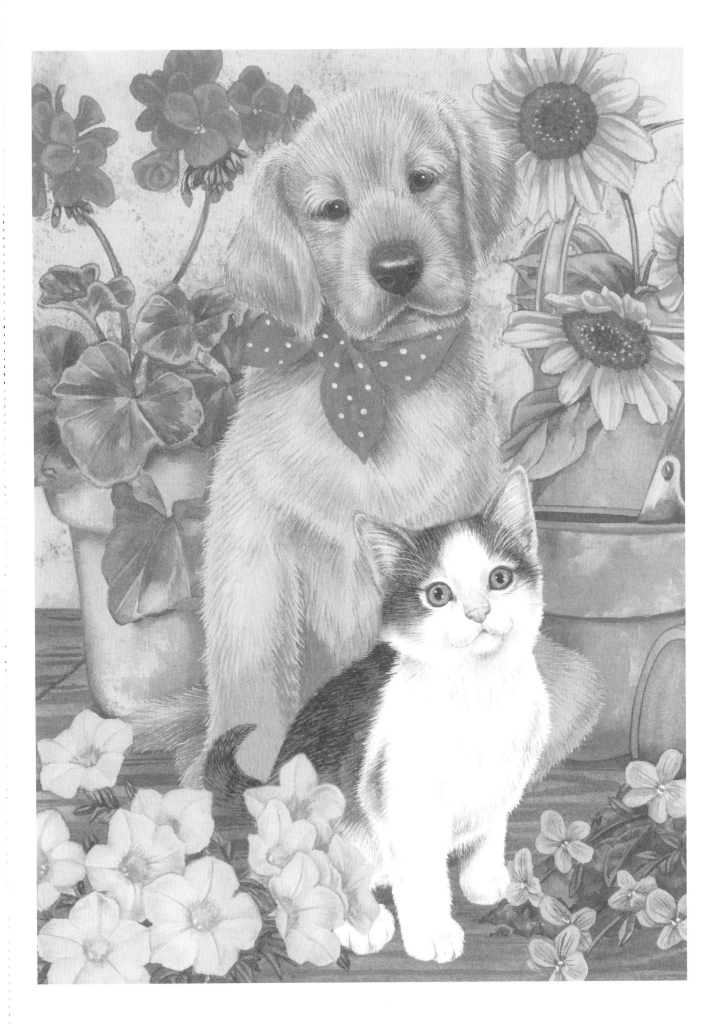

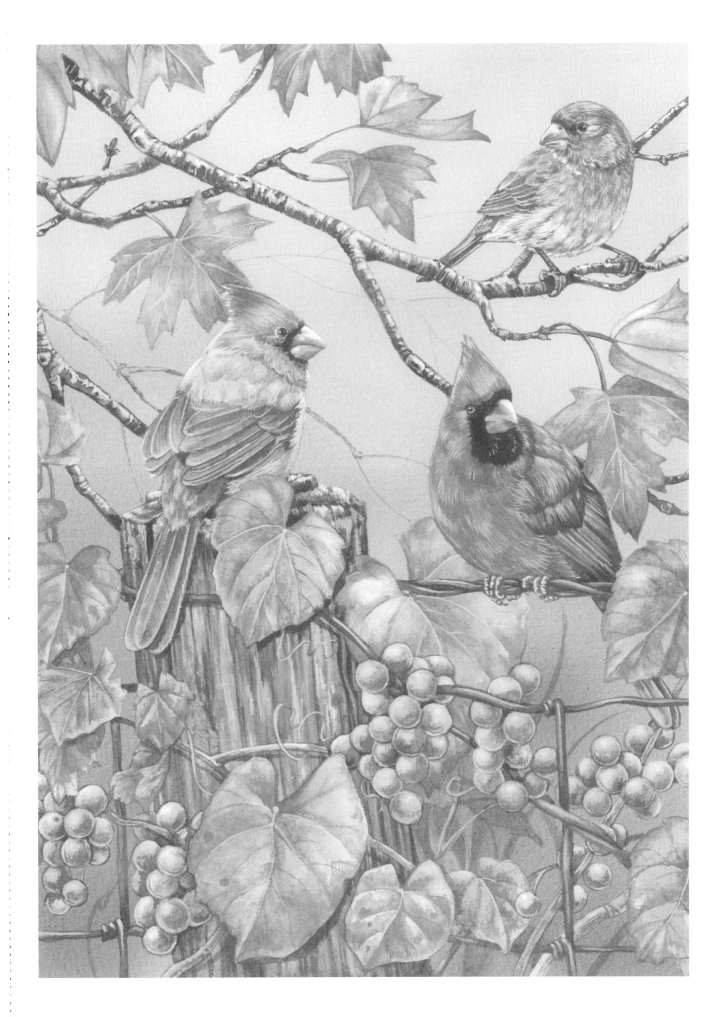

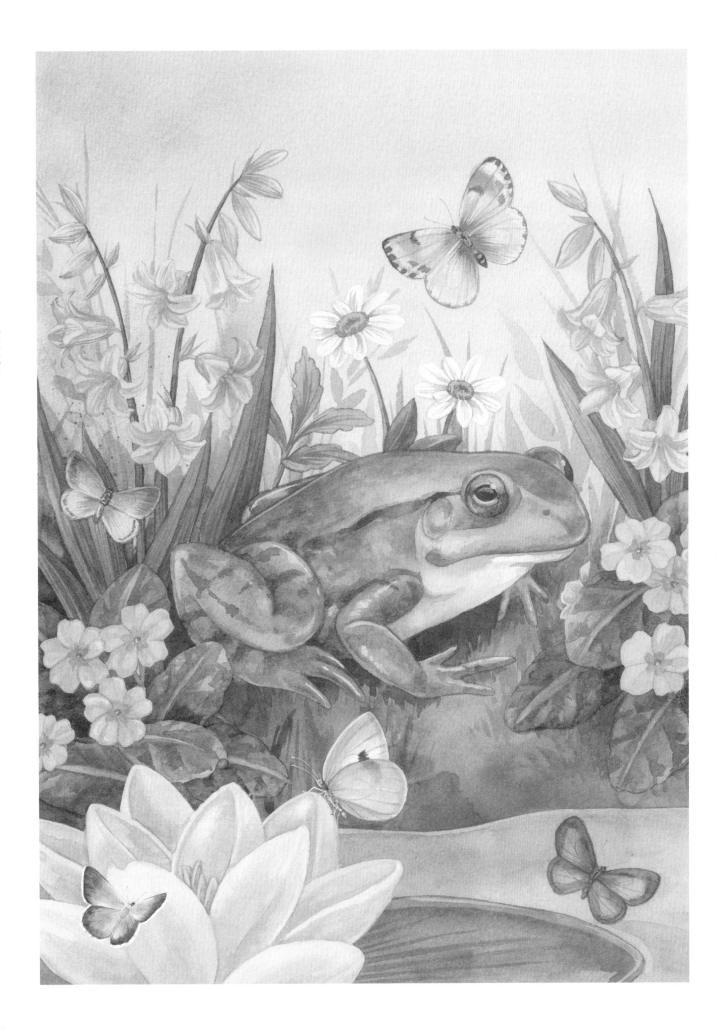

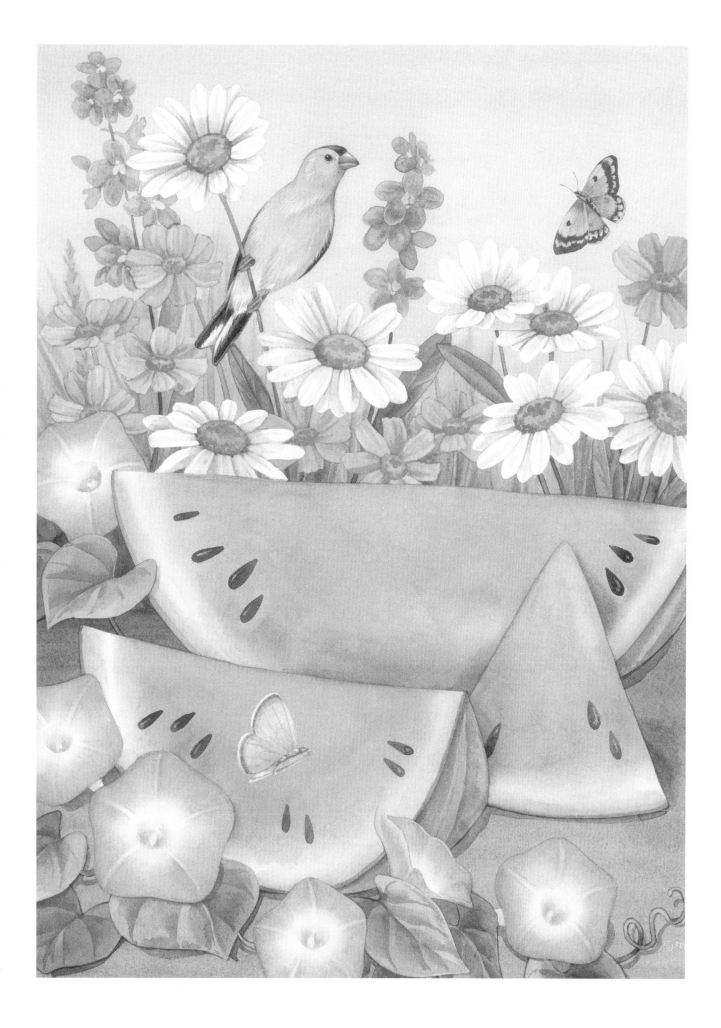

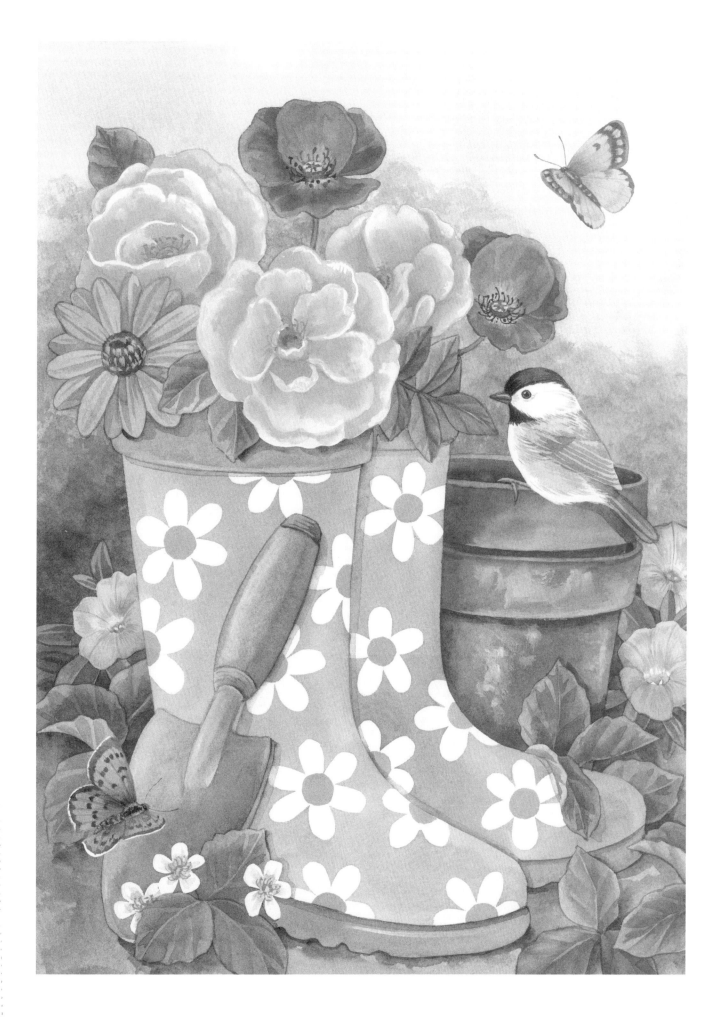

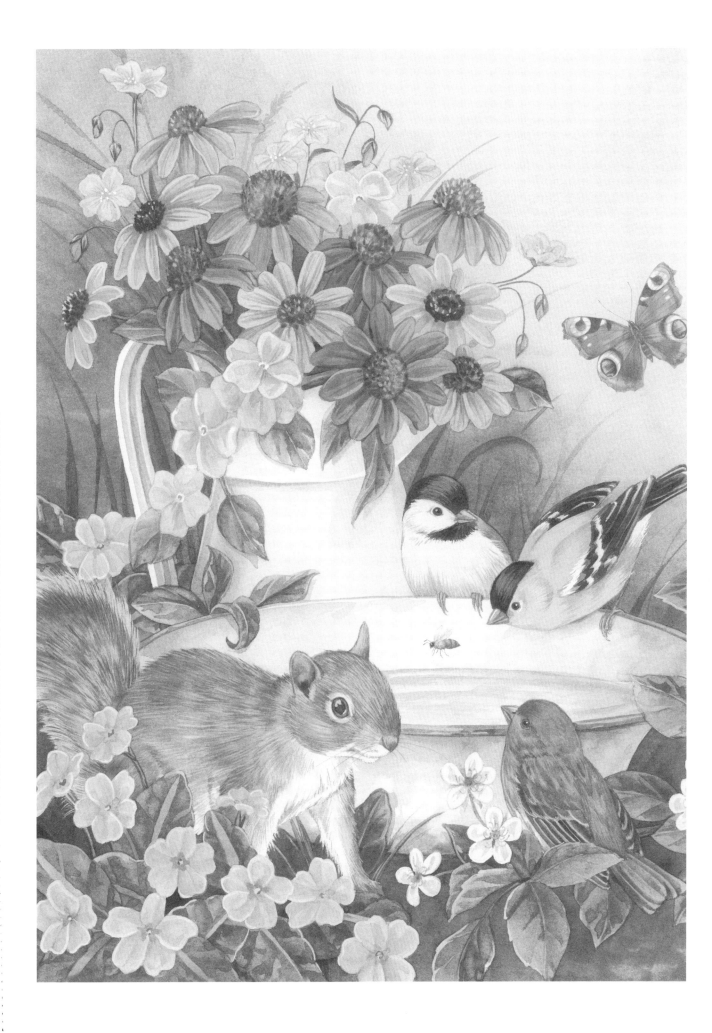

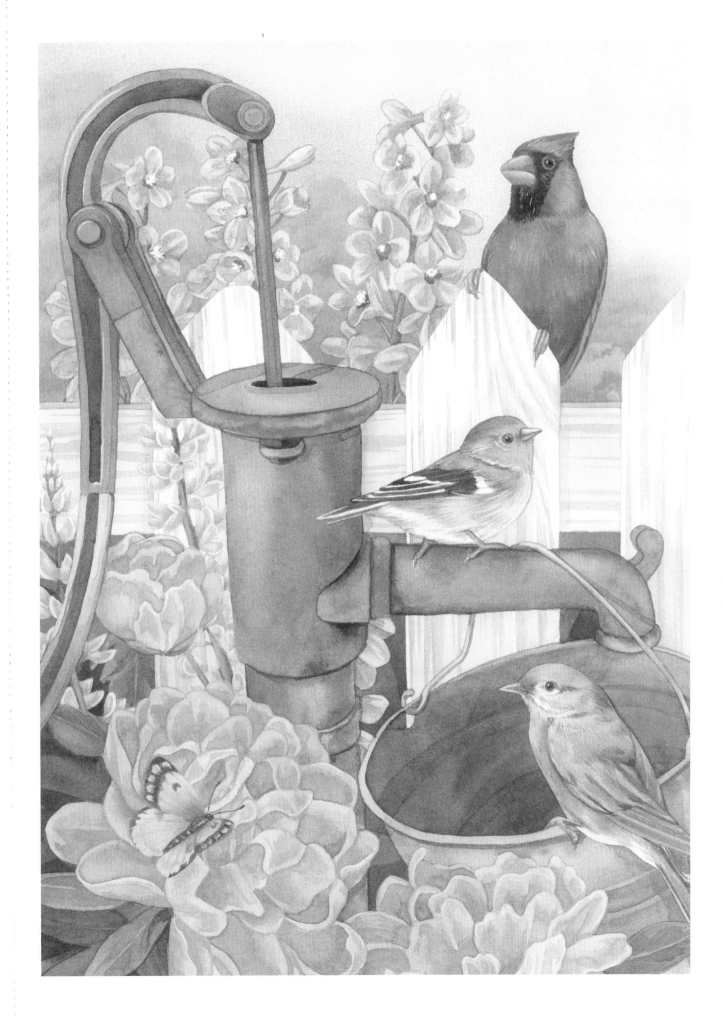

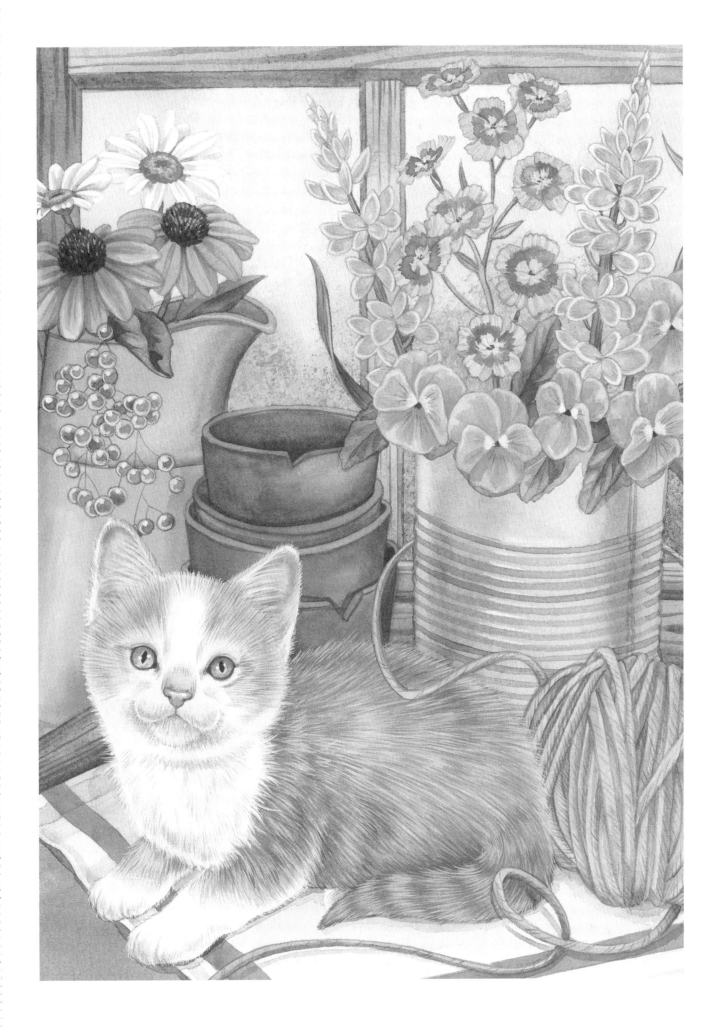

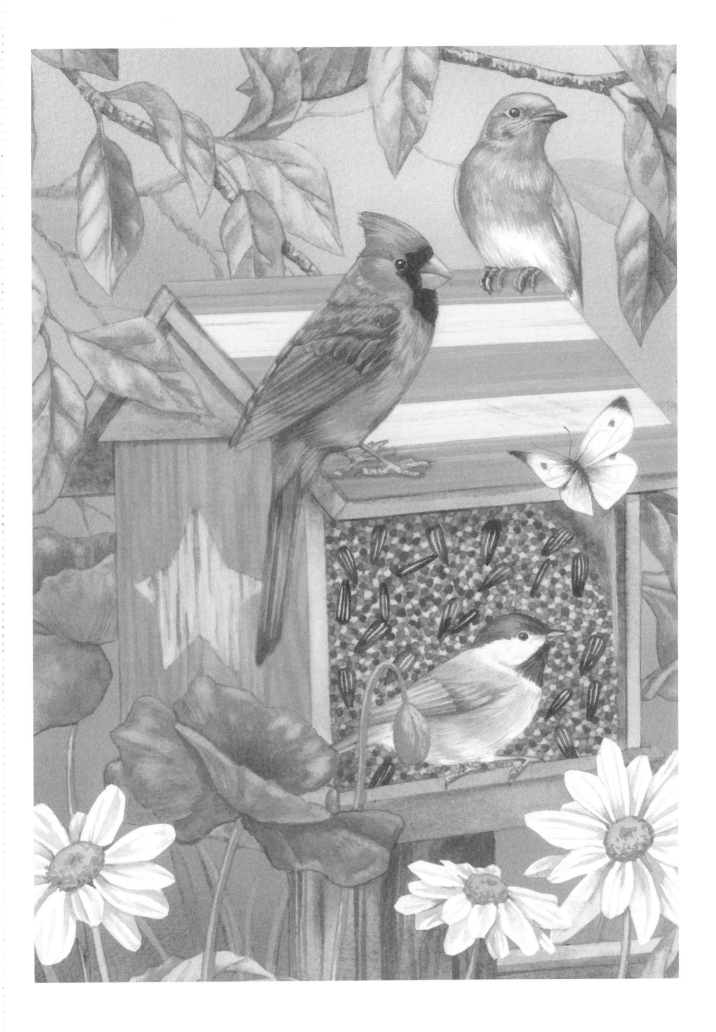

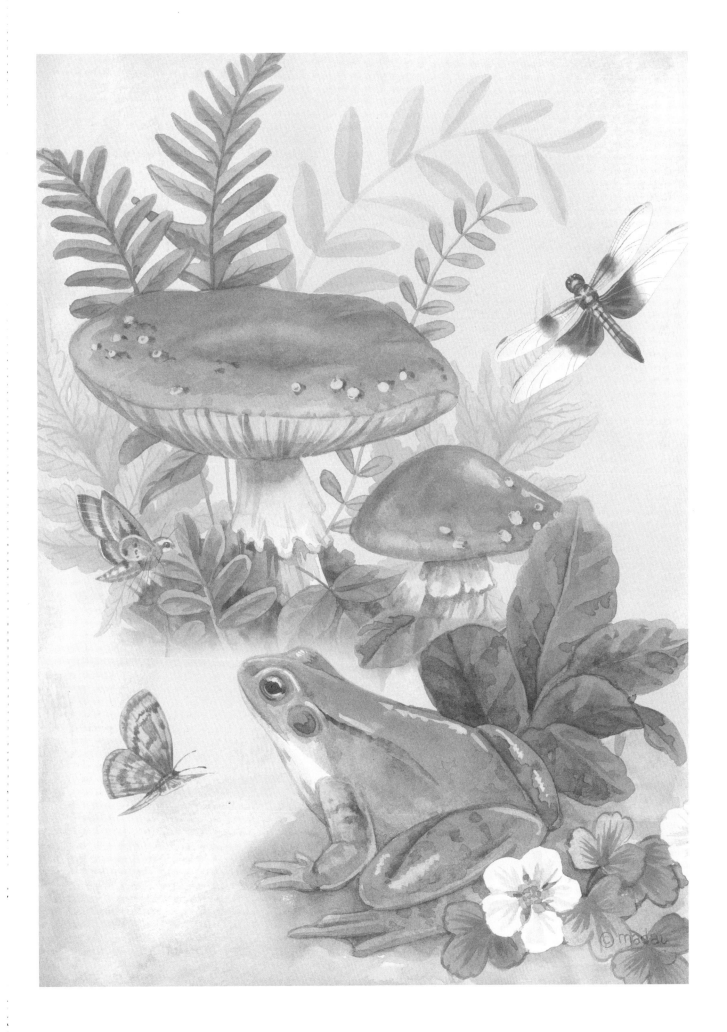

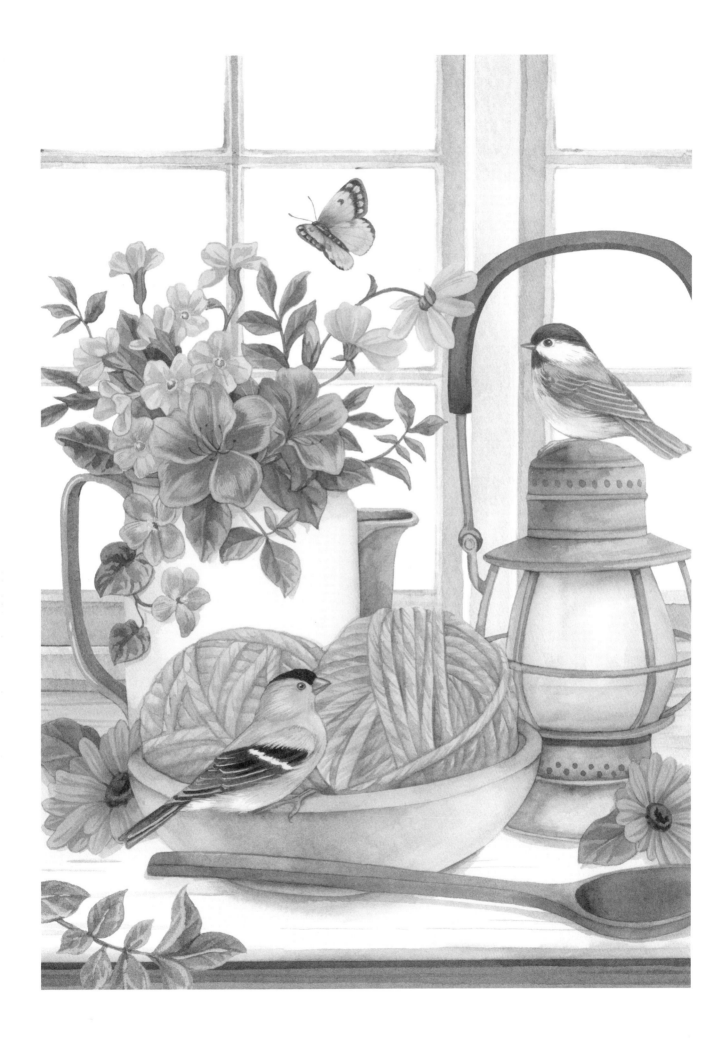

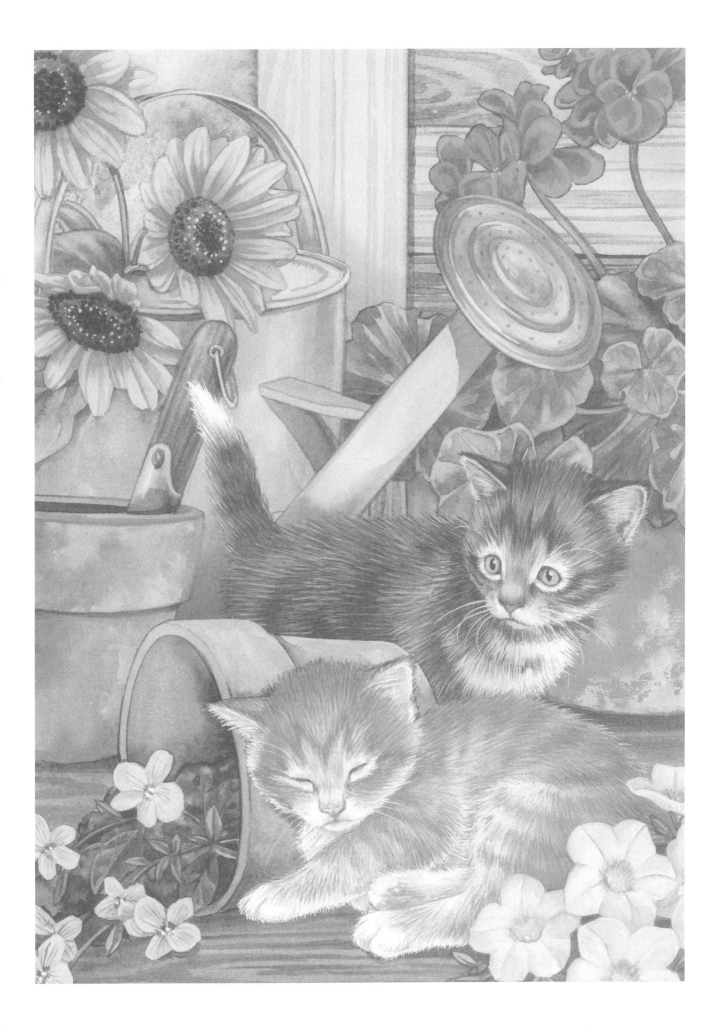

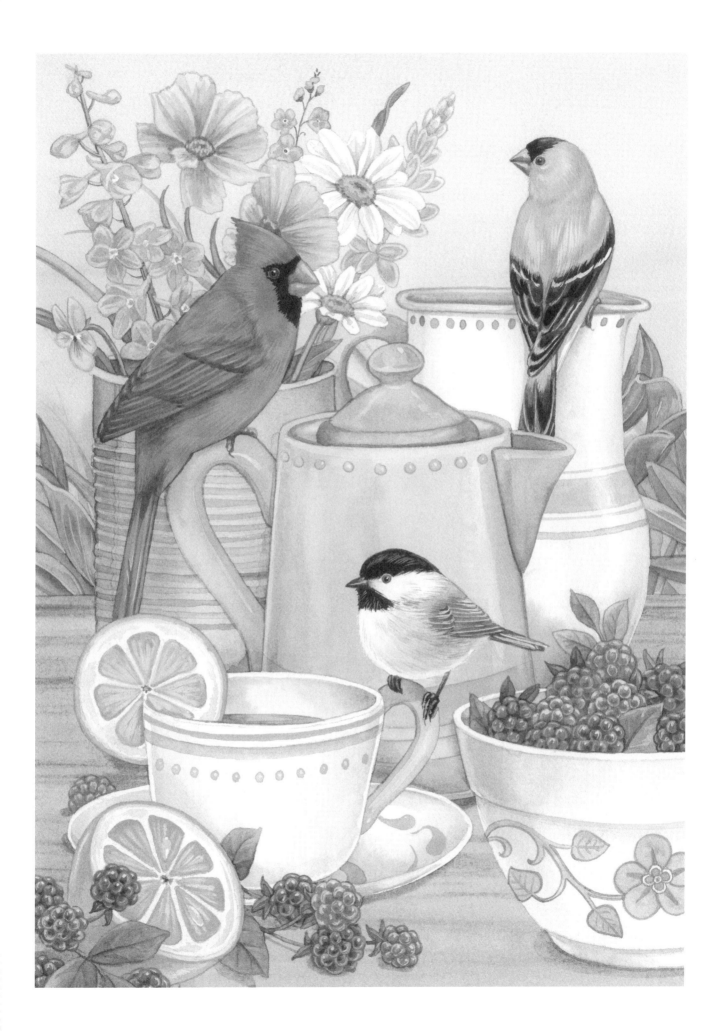

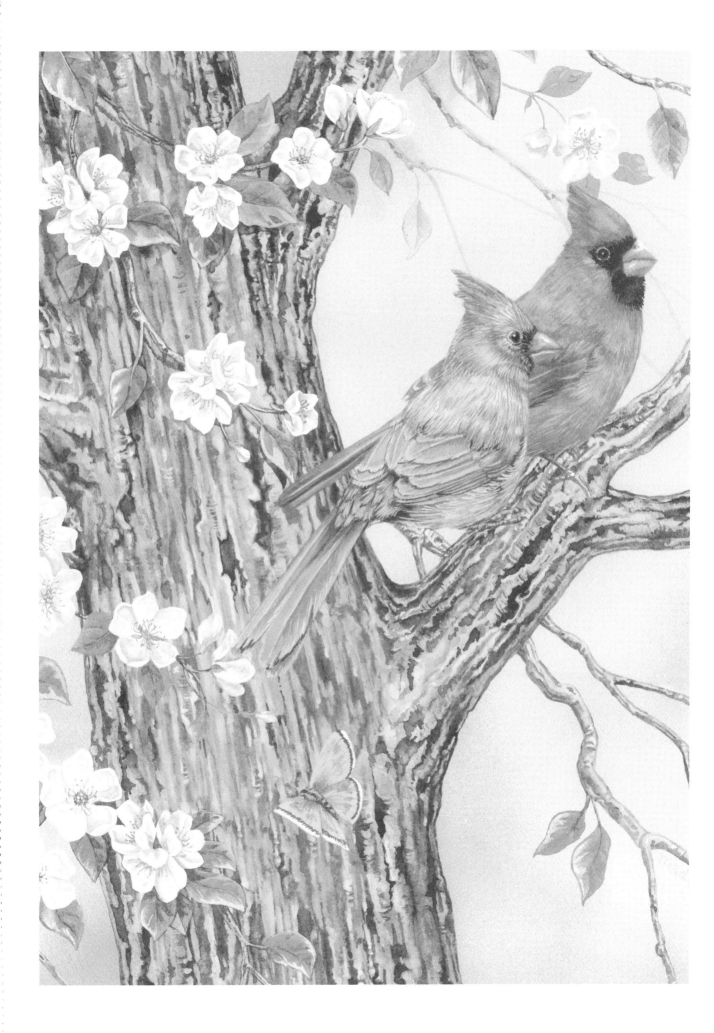

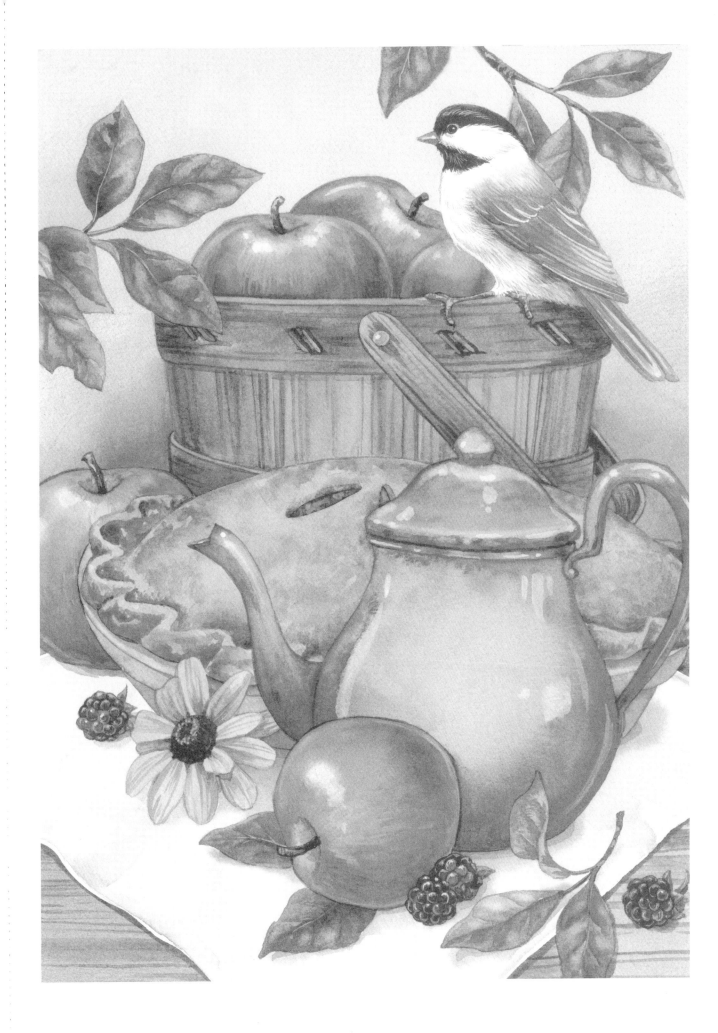

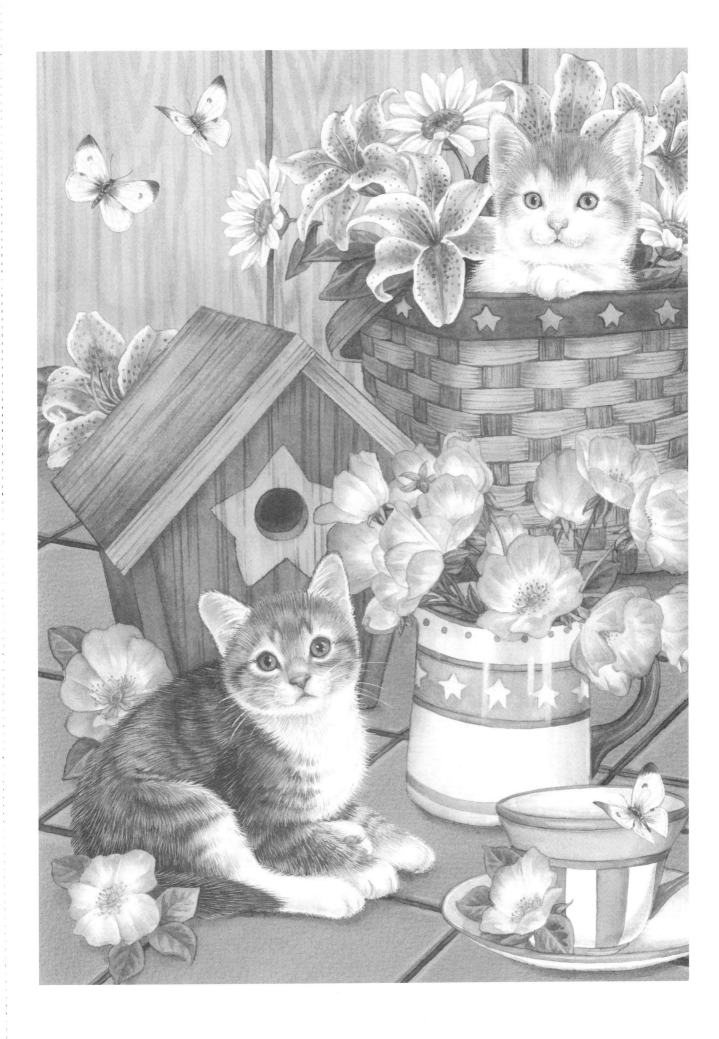

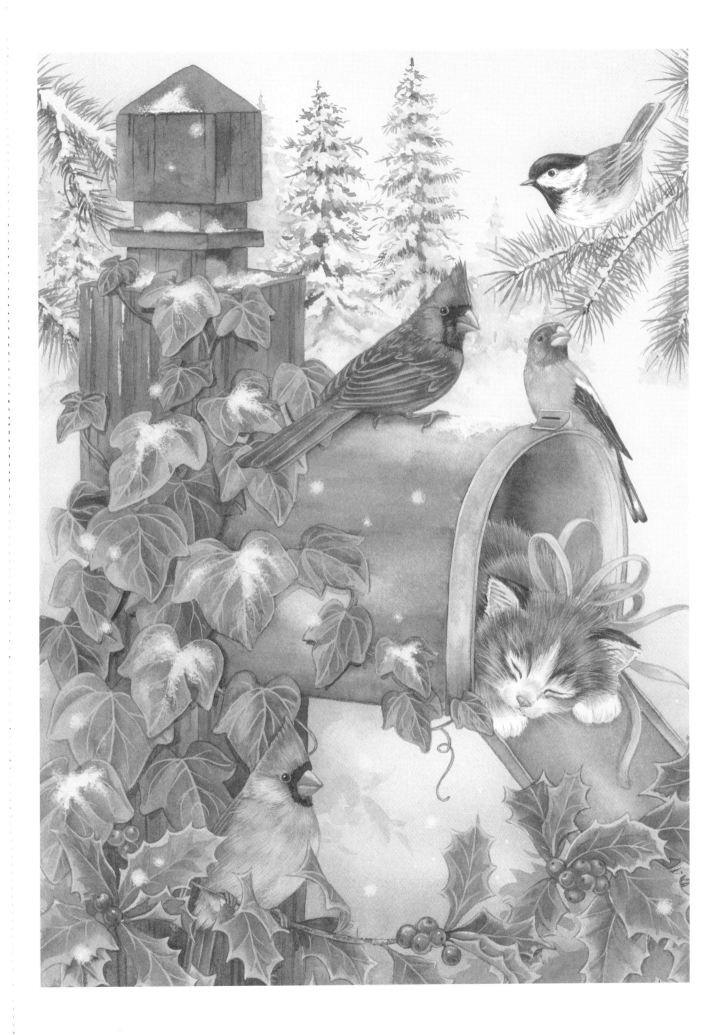

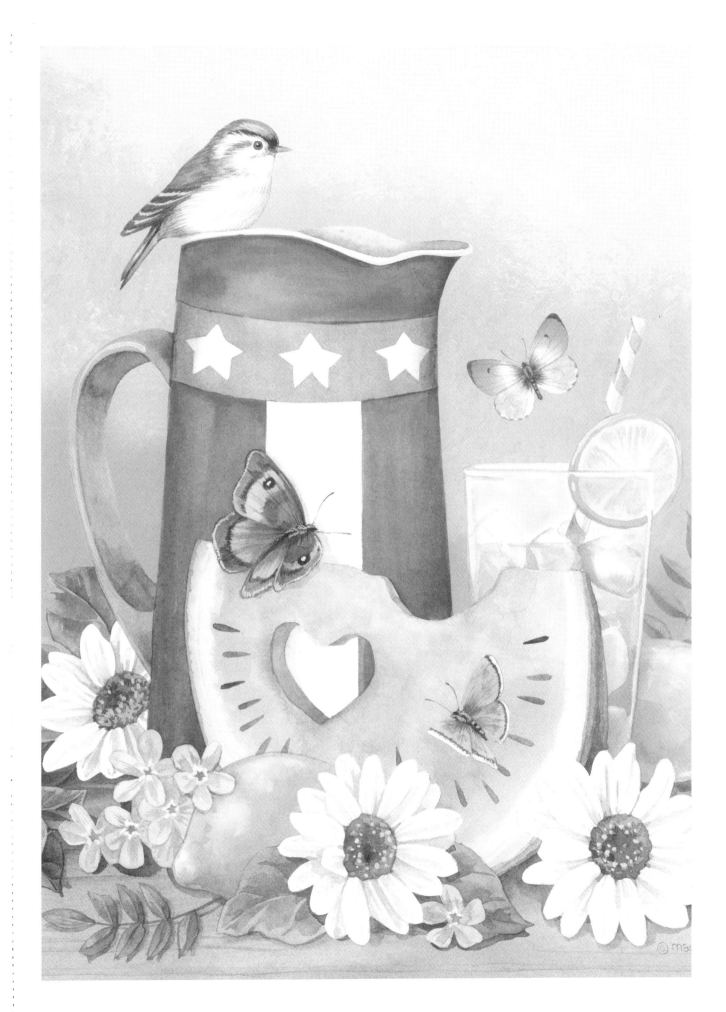

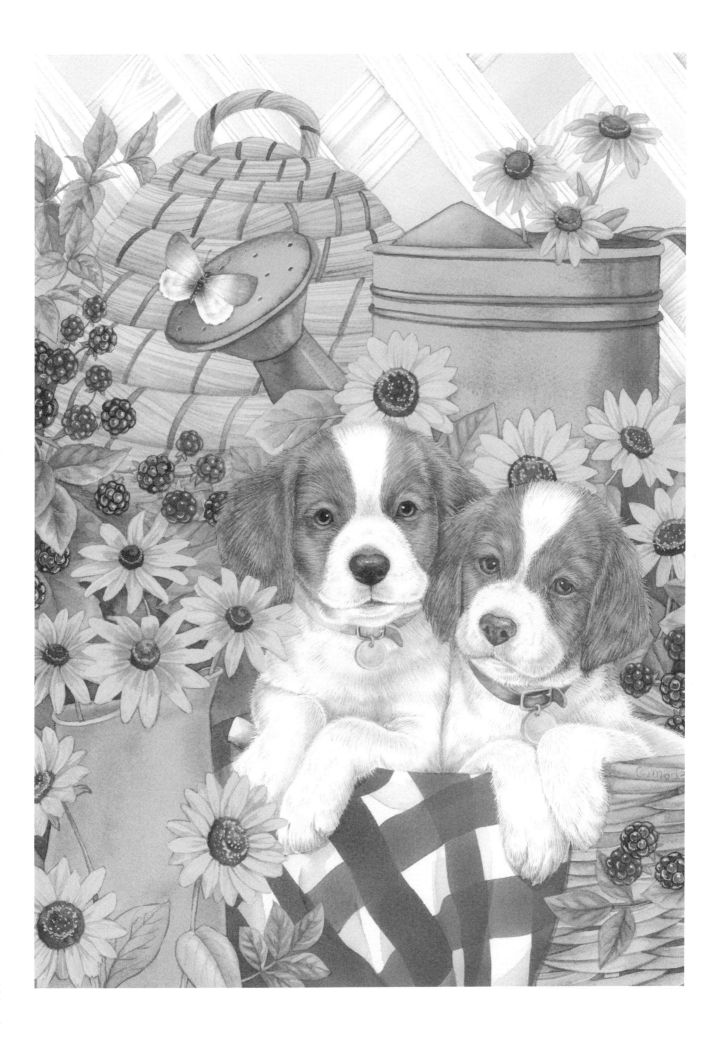

Inspiration Gallery

It can be a little intimidating to look at a full grayscale page and not know where to start. Some people find it helpful to see my original paintings to give them an idea for a color scheme. Refer to the colored examples on the following pages when you are getting started. You don't have to copy what I did, of course. The most important thing is to have fun!

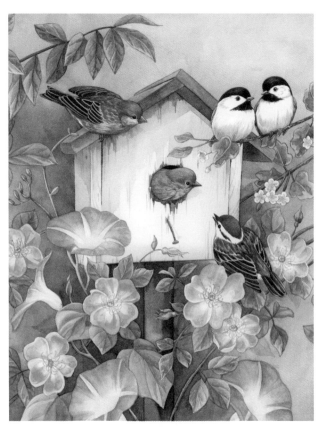

Blooming Birdhouse, page 17

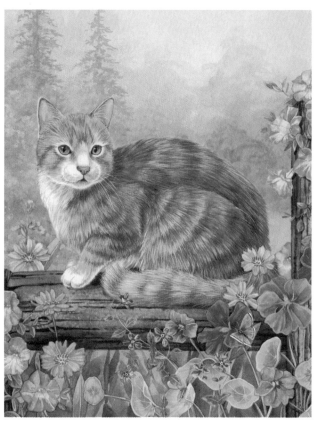

A Perfect Perch, page 19

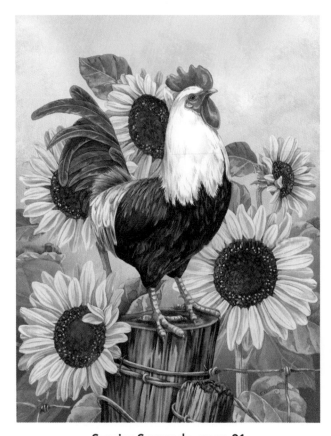

Sunrise Serenade, page 21

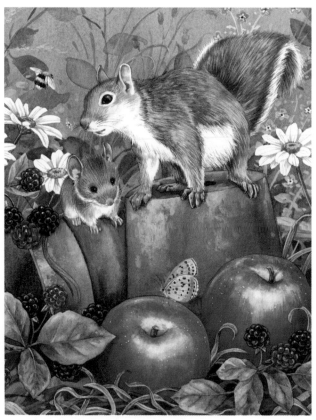

Garden Party, page 23

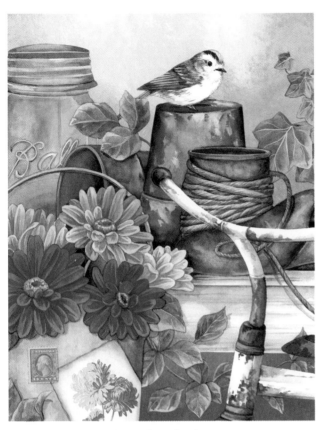

The Old Garden Shed, page 25

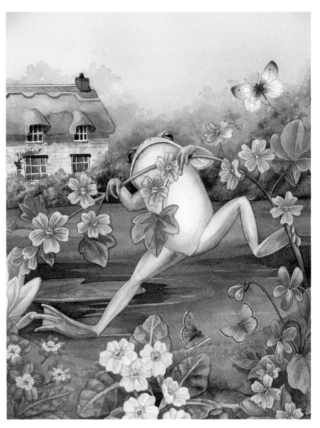

Don't Fall, Froggy, page 27

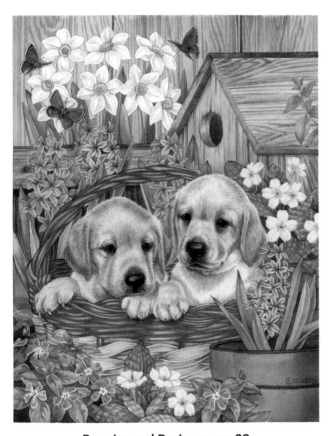

Puppies and Posies, page 29

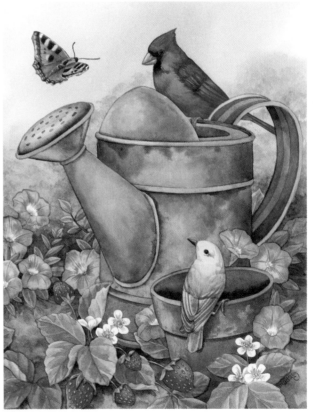

Garden Traditions, page 31

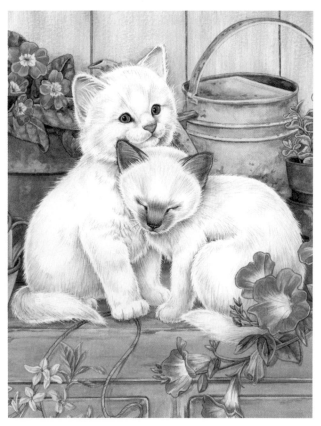

Tranquil Times, page 33

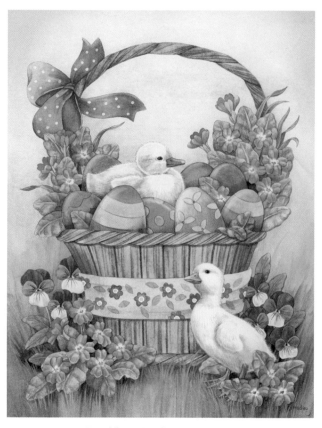

Duckling Basket, page 35

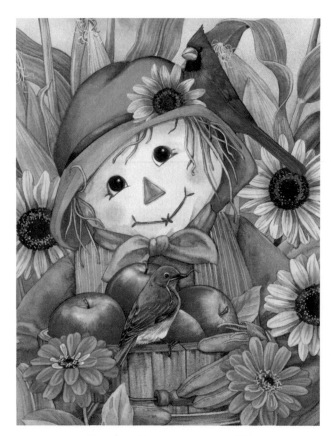

October Scarecrow, page 37

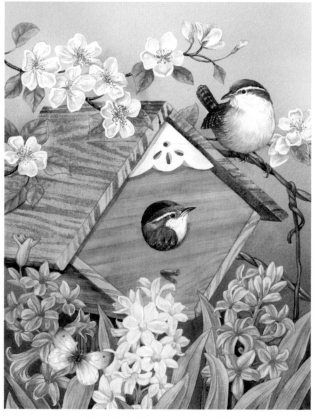

Hyacinth House, page 39

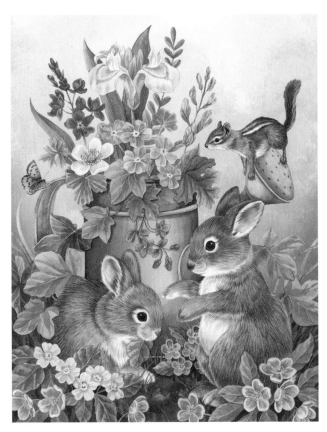

A Touch of Spring, page 41

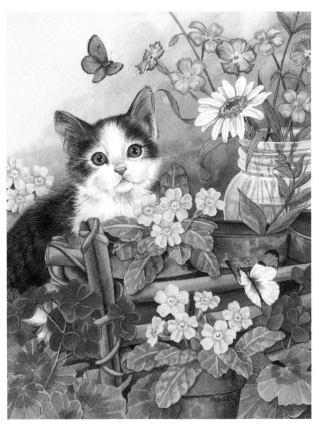

Gardener's Helper, page 43

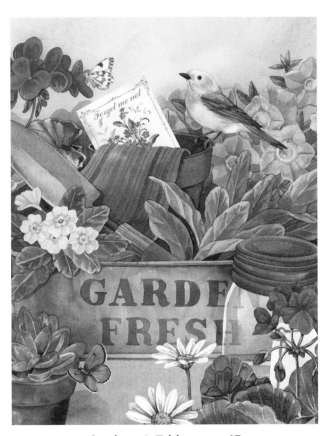

Gardener's Table, page 45

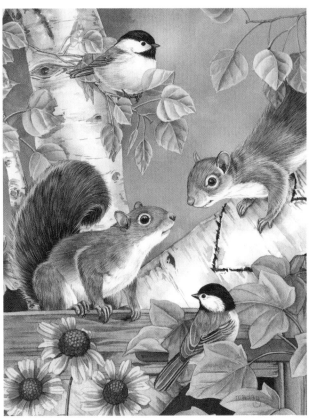

Autumn Romance, page 47

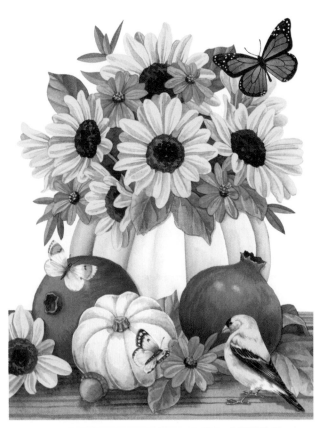

Pumpkins and Pomegranates, page 49

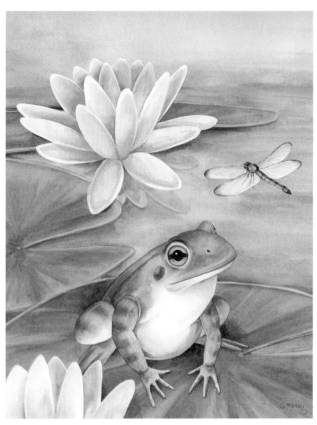

Lily Pad Frog, page 51

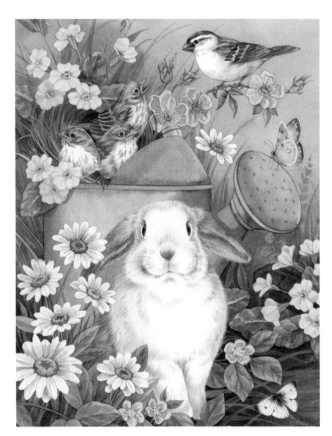

Spring Blessings, page 53

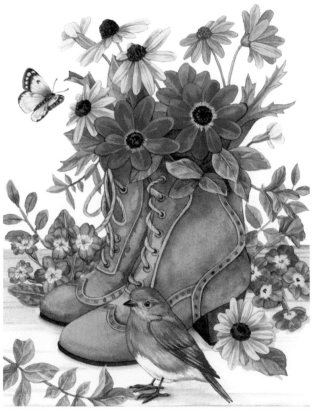

Lady's Boot Bouquet, page 55

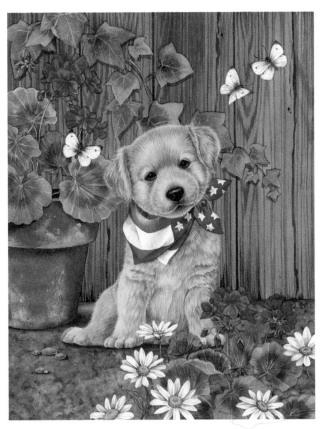

Patriotic Puppy, page 57

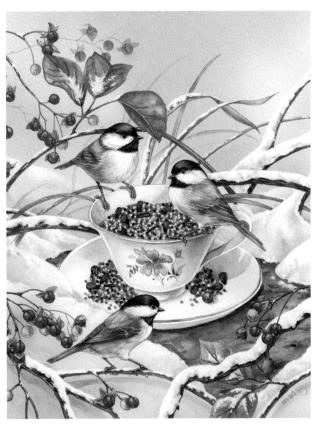

Chickadee Tea, page 59

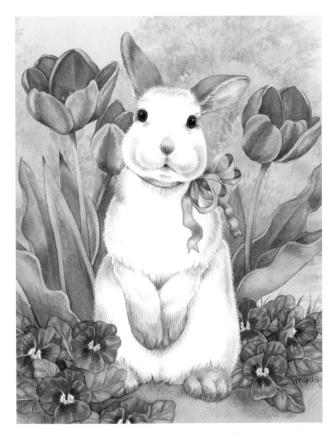

Standing Bunny, page 61

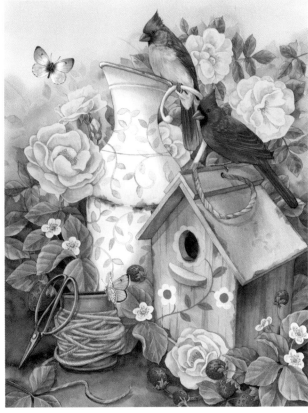

Cardinals With Yellow Roses, page 63

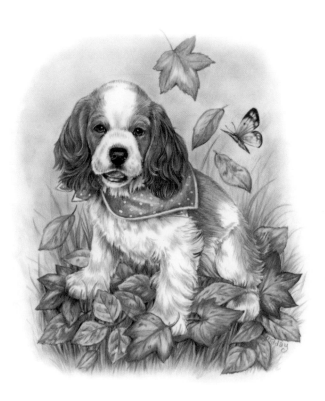

Dog With Leaves, page 65

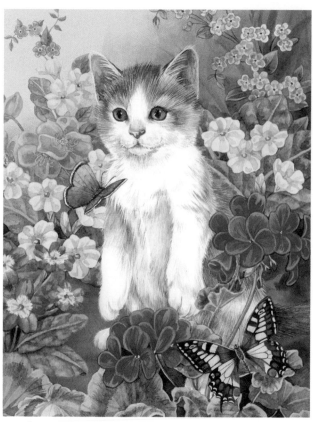

Playing With Butterflies, page 67

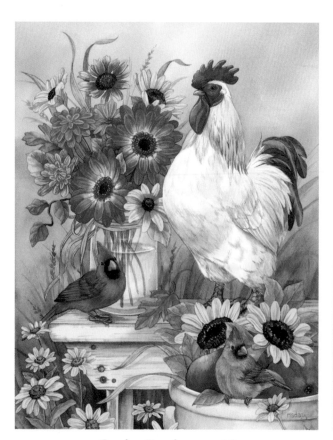

Garden Bench, page 69

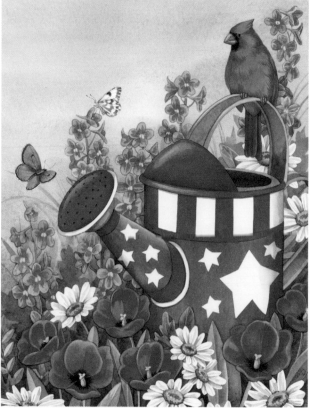

Patriotic Watering Can, page 71

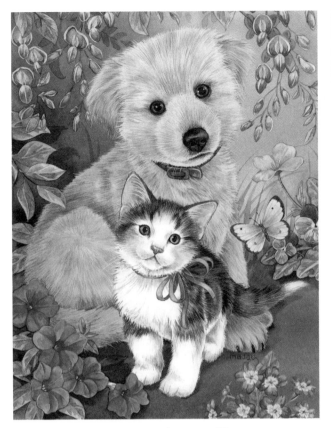
Best Friends, page 73

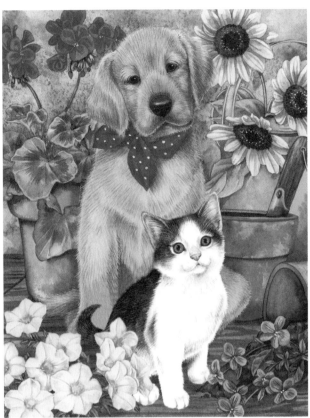
Babysitting, page 75

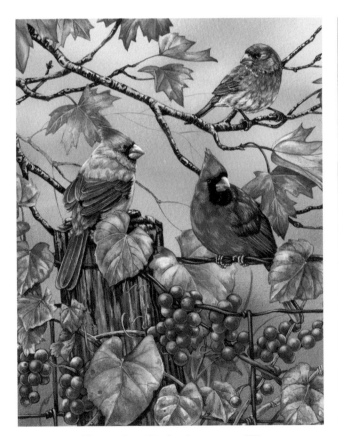
Grapevine Gathering, page 77

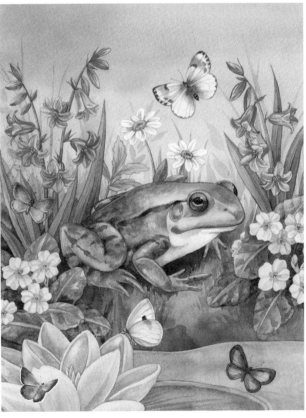
Garden Pond, page 79

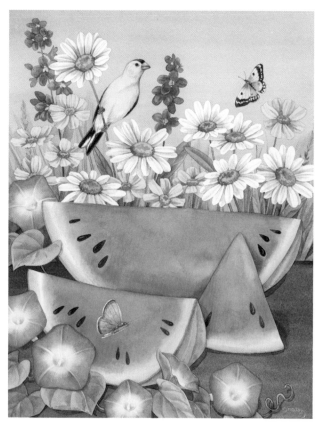

A Slice of Summer, page 81

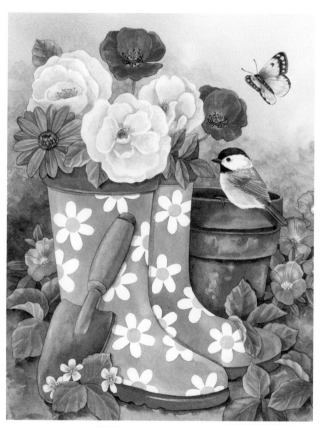

Garden Boots, page 83

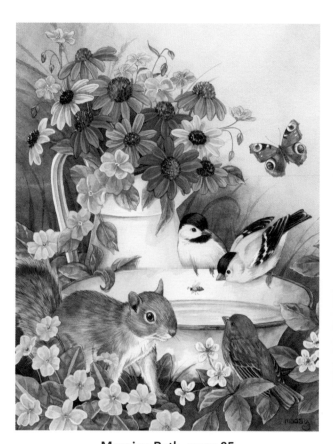

Morning Bath, page 85

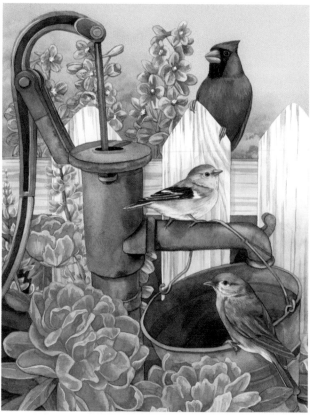

Peonies Pump, page 87

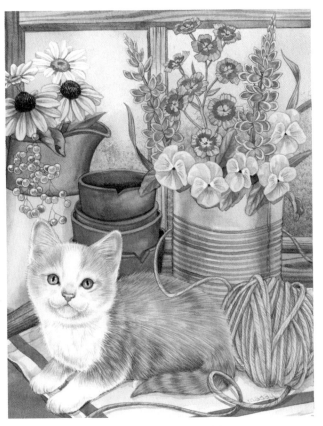

Twine Kitten, page 89

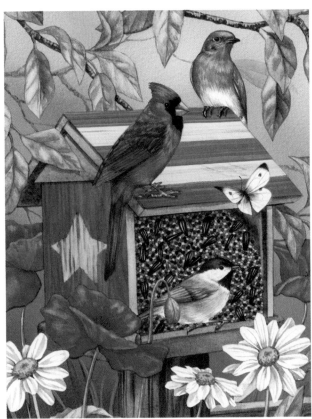

Celebrate Summer, page 91

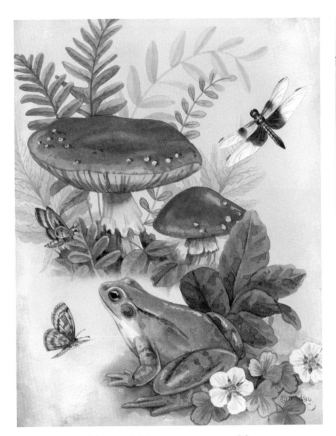

Nature's Treasures, page 93

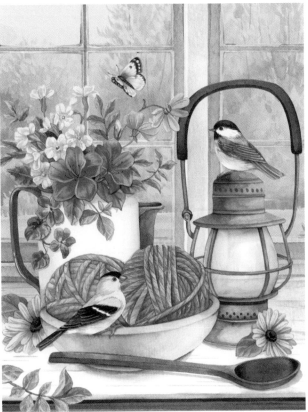

A Lady's Table, page 95

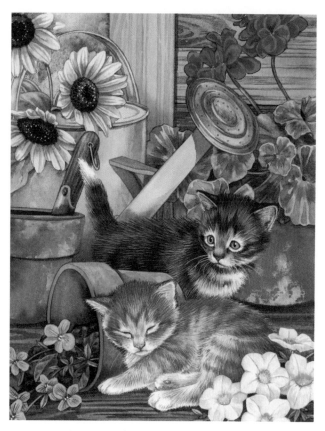

Kittens and Watering Can, page 97

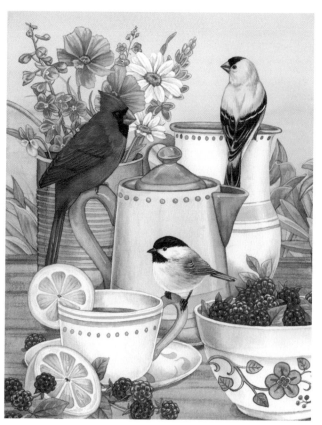

Raspberries and Lemons, page 99

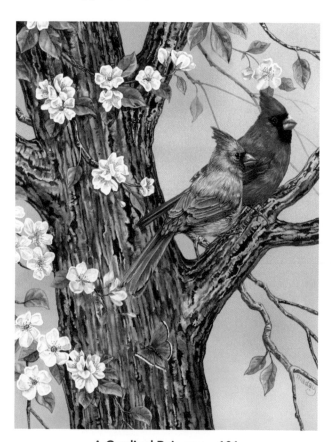

A Cardinal Pair, page 101

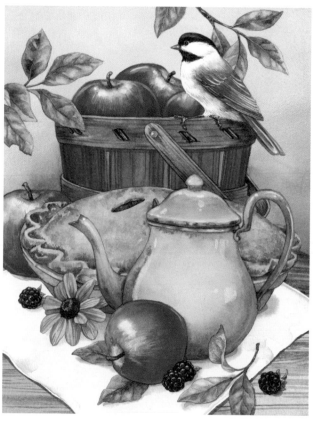

Picnic Pie, page 103

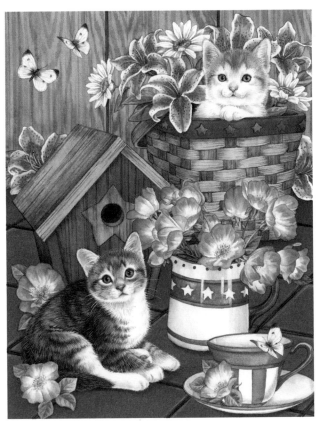

American Afternoon, page 105

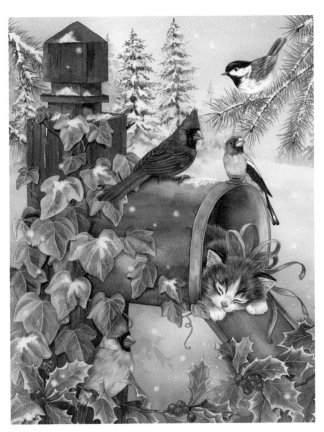

A Cozy Nap, page 107

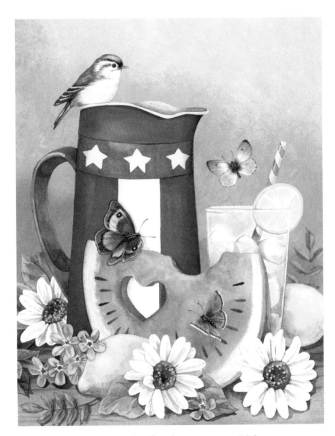

Summer Refreshers, page 109

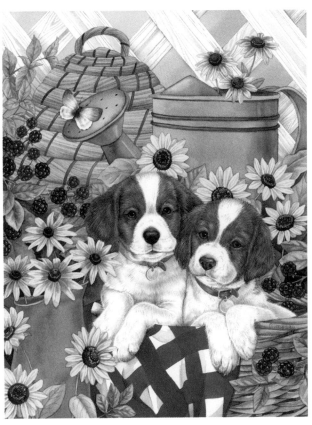

Brittany Babies, page 111

North Light Books
An imprint of Penguin Random House LLC
penguinrandomhouse.com

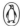

Copyright © 2017 by Jane Maday

Printed in China

10 9 8 7 6 5

ISBN 978-1-4403-5051-1

Edited by Sarah Laichas
Cover by Clare Finney
Interior design by Jamie DeAnne

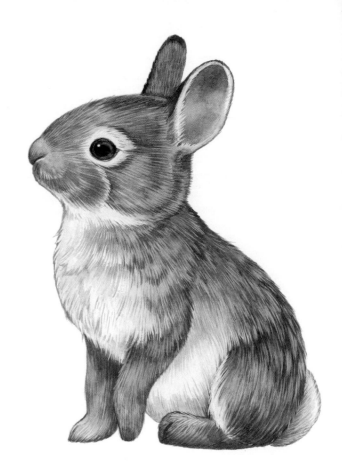

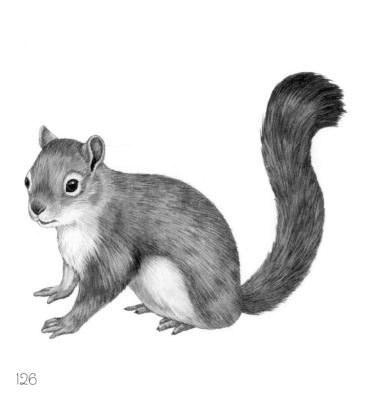

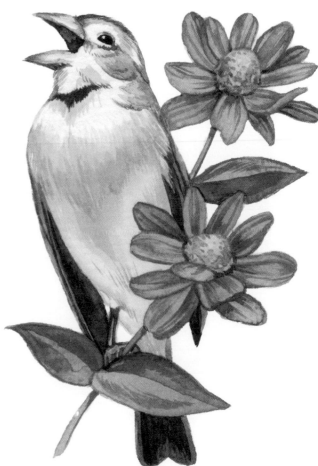

ABOUT THE AUTHOR

A graduate of Ringling College of Art and Design and a former greeting card illustrator for Hallmark, Jane Maday's work has adorned 25 children's books, as well as collector's plates, ornaments, cards, T-shirts, garden flags, jigsaw puzzles, and much more. Jane is the author of many magazine articles and the best-selling North Light art instruction book *Draw Baby Animals*. She has also authored three coloring books: *Color Super Cute Animals* (2016), *Super Cute World: A Coloring and Creativity Fun Book* (2017) and *Adorable Animals Grayscale Coloring Book* (2017). She lives in Fort Collins, Colorado.

Photo by Ian Gray

DEDICATION

For Margaret, my grown-up girl.

ACKNOWLEDGMENTS

Thanks to the gang at F+W Media, especially my editor Sarah. And special thanks to John, my hubby of thirty years, for putting up with me.

VISIT JANE ON FACEBOOK!

For more coloring fun and helpful tips, visit Jane's Facebook page and join the conversation!

 Jane Maday Studio: Creative Bliss

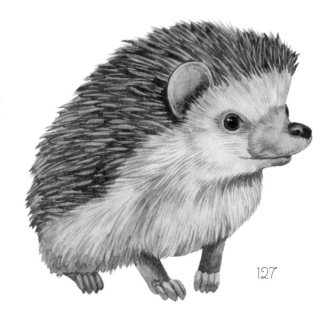

127

Ideas. Instruction. Inspiration.

NORTH LIGHT BOOKS